A LOAN EXHIBITION ORGANIZED BY THE FOGG ART MUSEUM 1963

ANDREW WYETH *Dry Brush and Pencil Drawings*

FOGG ART MUSEUM HARVARD UNIVERSITY CAMBRIDGE MASSACHUSETTS

THE PIERPONT MORGAN LIBRARY NEW YORK NEW YORK

THE CORCORAN GALLERY OF ART WASHINGTON D.C.

WILLIAM A. FARNSWORTH LIBRARY AND ART MUSEUM ROCKLAND MAINE

DISTRIBUTED BY NEW YORK GRAPHIC SOCIETY, GREENWICH, CONNECTICUT

Lenders to the Exhibition

WILLIAM A. FARNSWORTH LIBRARY AND ART MUSEUM, Rockland, Maine

DR. MARGARET I. HANDY, Chadds Ford, Pennsylvania

MR. T. EDWARD HANLEY, Bradford, Pennsylvania

MR. AND MRS. HARRY G. HASKELL, JR., Wilmington, Delaware

DR. AND MRS. MYRON A. HOFER, II, Washington, D.C.

MR. AND MRS. PHILIP HOFER, Cambridge, Massachusetts

MRS. FREDERICK H. LASSITER, New York, New York

MR. AND MRS. ROBERT MONTGOMERY, New York, New York

MR. AND MRS. W. E. PHELPS, Montchanin, Delaware

PRIVATE COLLECTION, New York, New York

MR. AND MRS. HENRY SALTONSTALL, Exeter, New Hampshire

MR. AND MRS. HAROLD S. SCHUTT, JR., Wilmington, Delaware

MR. AND MRS. R. L. B. TOBIN, San Antonio, Texas

MR. AND MRS. GEORGE WEYMOUTH, Chadds Ford, Pennsylvania

MRS. ANDREW WYETH, Chadds Ford, Pennsylvania

Acknowledgments

We wish to express our great appreciation to all the lenders for their generosity in parting with their drawings and dry brush sketches by Andrew Wyeth for the duration of this exhibition. Without their co-operation in all matters this undertaking would not have been possible. Our especial thanks go to Mr. and Mrs. Andrew Wyeth for their invaluable assistance, not only in the selection and dating of works to be exhibited, but also in acquainting us with the circumstances connected with the creation of these works. We pay particular thanks to Mr. W. E. Phelps for his thoughtfulness in bringing to our attention the illustrated letters of Andrew Wyeth, and to Mr. Helmut Ripperger of M. Knoedler and Company, New York City for his help in providing bibliographical material.

For their assistance in compiling this catalogue we wish to thank Mrs. Grafton Wilson and Mrs. Warren C. Moffett. Miss Emily Rauh of the Fogg Museum and Miss Eleanor Garvey of Houghton Library designed the catalogue entries.

A.M.

This catalogue was completed before the catalogue of the Andrew Wyeth Exhibition at the Albright-Knox Art Gallery in Buffalo, November 2-December 9, 1962, was available. Thus no reference to its entries could be included.

Foreword

In the finished tempera paintings of so thoughtful an artist as Andrew Wyeth, there is bound to be some loss of the immediacy which is such an outstanding characteristic of his dashing watercolors. A painter cannot always invent directly on his canvas or panel. Quick sketches and working drawings are often a necessary preliminary. The pity is that students and the public so rarely see them. Because of their intimate nature and unfinished state, the artist almost invariably hides them away, or—even more regrettably—destroys them. But they can be of the utmost beauty and importance as is evidenced by the Leonardo da Vinci cartoon long owned by the Royal Academy, Burlington House, London, over which there has been so much excitement in recent months.

For a number of reasons, therefore, the writer of this note was particularly pleased when Mr. Wyeth expressed his willingness to allow a considerable showing of his watercolor sketches, as well as a number of pencil drawings, because, with few exceptions, they have never been exhibited before. By far the largest proportion of them are in Mrs. Wyeth's personal collection.

Here, at last, can be adequately seen a very significant facet of the artist's genius: the connecting link between his watercolors and his paintings.

PHILIP HOFER
*Curator of Printing and Graphic
Arts, Harvard College Library
Secretary, Fogg Art Museum*

June 1, 1962

Introduction

A succession of exhibitions since his first, at the age of twenty, in 1937, and the generous reproduction of his work in color as well as black and white, has acquainted a wide audience with the tempera paintings of Andrew Wyeth. The almost haunting suggestion of drama evoked by his representations of seemingly naturalistic scenes, such as *Christina's World* (see number 3), and the changing moods of winds and seasons, recorded in the sombre yet dashing watercolors, have awakened responsive chords of understanding throughout the country. More than once the artist has described to sympathetic interviewers his manner of procedure, from the first idea to the finished picture. Yet, as Mr. Hofer points out, this is the first time that an exhibition has been devoted not to the temperas and watercolors but to his preparatory studies, both those in pencil and those that he calls "dry brush."

That the gifted son and pupil of the noted illustrator and painter, N. C. Wyeth, should be an accomplished draughtsman is not surprising. The elder Wyeth, his son has said, believed in "sound drawing." He was highly critical of his pupil's work. The young artist, whose health for many years was not robust and who for this reason remained near parental tutelage, profited from the stern discipline. As a result, he found himself, when still a young man, equipped with a tool ready to record with speed and exactitude, sometimes in the quickest of notations, ideas, scenes, or details which once recorded he could contemplate, analyze, or even reject, as

plans for a picture evolved. His pencil drawings are generally details that will find a place in the whole. The dry brush technique carries plans beyond the quick watercolor sketches. They are a step nearer the finished work. Since the tempera technique is, by its very nature, a slow and exacting one, the helpfulness to the artist of the intermediate step is clear. Many changes in tone, mood, and details can and often do take place between the dry brush and the painting. Since they have been steps on the road to another goal, the artist and his wife have often kept them.

As its name suggests, the dry brush technique is neither as quick nor as fluid as watercolor. The color itself is more dense, yet never so heavy as to lose all translucency.

To show the steps through which Wyeth's paintings have evolved, we have reversed the usual order of catalogues. Generally drawings and studies are listed after the more completed works. In this instance, it seemed more reasonable to place them in the order in which they were done. In one case a dry brush drawing is itself the completed work: The Young Bull (number 67). Of this subject, there is no tempera painting. One of the artist's most recent works, it is also one of his most fascinating—and the manner in which it came into being contains so many steps and elements characteristic of his procedure that it can serve as an illuminating example of his particular and personal creative method.

First of all, the setting is one familiar to him in many seasons and in many lights: the house, hill, and wall of his neighbor, the German farmer, Karl Kuerner. We know from a letter to his friend and neighbor, Mr. Phelps, written in January 1957 (see number 38), how, walking early one win-

ter morning, he saw the pale winter light strike the upper story of the square white house, and, going nearer, he saw the ropes and chains which the farmer used when slaughtering his hogs. The two events made such a sudden and deep impression that he made a detailed pencil sketch of the fork of the beech tree with its rope and chains and enclosed it in a letter which not only described the walk and the morning but illustrated, in tones from golden through mustard to dark bistre, on the letter's first page, how the scene had looked. The artist returned another day to find the young brown Swiss bull near the wall, held by his owner. Sketch after sketch followed. It was not until three years later that the dry brush was considered finished. The early morning winter light was still striking the white house above the shadows, but the farmer and even the suggestion of chains had been eliminated. The young bull now stands in profile in transparent shadow, facing the coming day, the shadows of his ears and legs, long echoing parallels to the shadow on the wall.

It was in that letter of January 1957 that the artist wrote: "This is my time of year." One sees and one feels his excitement in the first sketch as he walks the beloved, familiar hills, noting the dry grass, the lowering clouds, the drift of snow, the flight of birds. But one suspects that each season is his, as its eternal changes unfold. His is a countryman's trained eye, but his is also the artist's sensibility. He knows every shift of wind and alteration of weather, whether in Chadds Ford where he was born and grew up or in the Penobscot region of Maine where he passes long summers. And so sure is his knowledge and his touch that one feels the drawing in of winter, the heaviness of March snow, the thinness

of February sunlight, the miracle of Quaker Ladies flowering as one watches—or senses the damp of Maine fog, the exhilaration of a northwest wind, or the still clarity of an autumn morning.

If, in general, the settings are nature's, the latent dramas are man's—forlorn, ancient houses looking out with blind eyes, each seeming to enclose the setting of some sad story; and abandoned implements—wagons, weights, a measure, useless without man's directing hand. Occasionally there is the evidence of what that directing hand accomplished, such as the dead deer swinging stiffly like a gallow's frozen corpse in the winter wind. The body can give its evidence without its presence as obviously as has the invisible hand—*Horace's Coat* (number 34) with its frayed edges and worn curves is, in a sense, a portrait of the man whose shape it has taken, as are *That Gentleman's* slippers's (see numbers 49 and 55). The empty bed (number 36) with the invalid's needments at hand is as eloquent as the painting with its frail occupant. *The Boots* (number 9) bearing down on the weeds beneath come forward with an inexorable finality, like Death itself.

Those who speak of "realism" and "photographic accuracy" have been misled by the artist's success in creating the image he sought. They have overlooked or not suspected the suppression of some details, the marked emphasis of others, the widening out or narrowing down of space, and the always careful adjustment of light. How all-important this role of light and shadow is, is immediately clear in the pencil drawings and in the dry brush studies, whether subtle, as in its play over the surge of *Kuerner's Hill* (number 2), or delicate yet precise as in *Winter Bees* (number 54) and *Vinal's Point* (number 62), or strong and power-

fully suggestive as in the *Olson Farm* (number 4) or the study of the oil drum (number 31). It is this acutely observed and recorded angle of light that gives the sense of an exact moment of vibrating time.

In the drawings one can see the artist sharpening the drama, even changing the seasons. Sometimes he manipulates the various factors so that there is an almost eerie quality, as in *Teel's Island* (number 25). Following his steps from the moment in June when his boat crunches onto the shore of that abandoned, silent spot, with a Northern sea all about it and sparkling air above, until he withdraws in the autumn, his last touch added to the drying grass, we, too, come to know how charged with a variety of emotions every scene is. The artist has known the people, their histories, their possessions, and their setting. Their lives have touched responsive springs in his being—from that response has come his power to move us. Inanimate objects—an abandoned oar, an empty crab shell, an abandoned house—are vivid with a symbolism no less valid for its seeming simplicity.

When he was young, every clump of dried grass, every leaf, was separately studied, but he found that in pulling his composition together he lost a certain immediacy. Some of his own first excitement failed to carry over. Today the studies he makes are less meticulous, less finely detailed. They have grown in sweep and authority. The speed of some, such as that which gives the whole composition of what will be *The Young Bull* (number 66), shows Wyeth following the same procedure as that followed by some notable artists of the seventeenth and eighteenth centuries whom one would not have thought of as his forebears, and

whom he, who has refused all foreign travel, would not claim.

As is true of every real artist, his preference and use of color is deeply personal, again often with symbolic overtones. He loves the colors of dry grass and of fresh green grass, and the russets of autumn leaves, "the dusty beauty" of a winter beehive, olive-greens and mustardy yellows, the contrast of silvery and golden tones, and over and over a note, or more than a note, of blue: the faded, worn blue of an old denim coat, a blue measure, a blue scale, a blue mussel shell, a patch of blue water, a bit of blue sky, a box or two of blueberries.

In the best sense of the word, Andrew Wyeth is a regional artist, for the scenes he draws and paints are chosen from the two regions he knows and loves so well. But in the last analysis the drawings and paintings are no more regional than the seasons themselves and the effects these seasons have on the lives of those who live in and through them.

AGNES MONGAN
Assistant Director and Curator
of Drawings, Fogg Art Museum

Catalogue

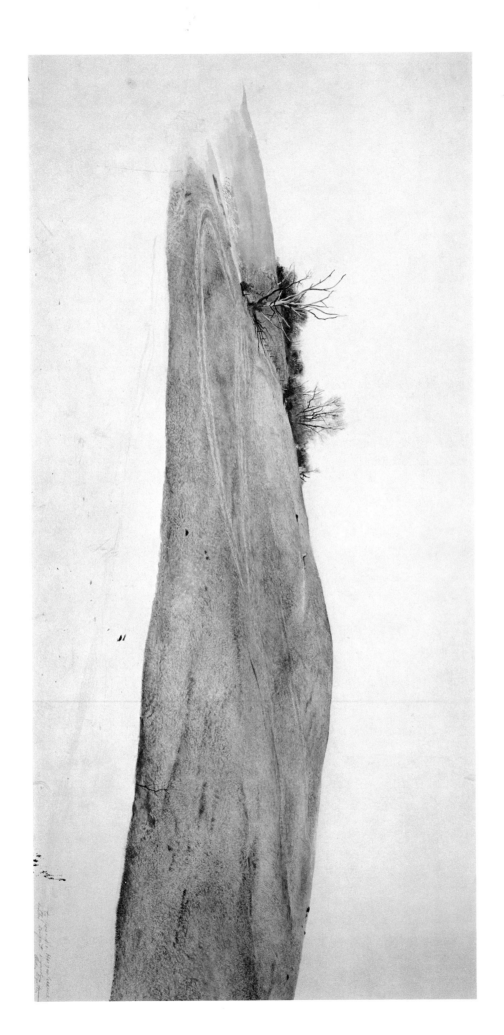

1 GRASSES

A clump of dried weeds and grasses and a dry leaf, painted just as the artist found it in a winter field.

Dry brush in tones of yellow and brown
17 × 21½ inches
Date: Autumn 1941

This drawing is a preparatory study for the tempera *Winter Fields* in the Collection of Mrs. Josiah Marvel, Greenville, Delaware (reproduced: *Art News*, vol. XLII, Mar. 1–14, 1943, p. 20). For the tempera, one of his early paintings in that medium, the artist made very complete preparatory studies, of which this is one in dry brush.

LENT BY MARGARET I. HANDY

2 KUERNER'S HILL ILLUSTRATED

In the middle distance is the gentle slope of a grassy hill, its green-gray grass marked by cart tracks. From the left a path bordered by a fence passes at an angle inward towards the right beyond a dead tree and up the hill towards a copse of leafless trees. The foreground is blank but a figure is lightly sketched in pencil at the beginning of the path at the left.

Pencil and dry brush in tones of gray, gray-green, and sand color
22 × 44 inches (sight)
Inscribed and signed at lower right: to Joseph Hergesheimer/with deepest regards/Andy Wyeth
Date: November 1945

The drawing is a preparatory study for the tempera painting, *Winter*, 1946, in the Collection of Mr. and Mrs. John MacDonald, Cambridge, Massachusetts. The tempera was finished by March, 1946, and is the first picture which Wyeth painted after his father's death (reproduced: *Art Digest*, vol. XXI, Oct. 1946, p. 10). N. C. Wyeth, muralist, illustrator, and teacher (1882–1945), was killed in an automobile accident at a railroad crossing the other side of Kuerner's Hill. The hill is one he used to sit on, as he contemplated the landscape. The same hill, seen from another direction, appears in the background of *Young Bull* (number 67).

LENT BY MR. AND MRS. R. L. B. TOBIN

3 CHRISTINA OLSON

She sits on the ground, facing inward, her hair loosely pinned and blowing in the wind.

Pencil on white paper
14½ × 20½ inches (sight)
Date: Summer 1948

The drawing is a preparatory study for the figure in the foreground of *Christina's World*, Museum of Modern Art, New York (reproduced: *Art News*, vol. XLII, Mar. 1–14, 1943, p. 16). Christina, a summer neighbor of the Wyeths' in Cushing, Maine, was crippled by infantile paralysis. Wyeth came upon her one day near the family burying ground looking at her house from the wide field in front of it. From the memory of this incident he developed the tempera painting. He also painted her in 1947 seated on the threshold of her open doorway (tempera, *Christina Olson*, Collection of Mr. and

Mrs. Joseph Verner Reed; reproduced: *Ten Color Reproductions of Paintings by Andrew Wyeth*, Triton Press, New York, 1956, no. 1), and again in 1952 (tempera, *Miss Olson*, Collection of Mr. John D. Rockefeller).

LENT BY MRS. ANDREW WYETH

4 OLSON FARM ILLUSTRATED

The three-story, clapboard farmhouse with its steep, shingled roof crowned by two slim chimneys above two dormer windows, stands unadorned at the edge of a field. Sunlight strikes it obliquely from the right. A ladder leading to the front gutter partially blocks the front door; it is joined by another which lies against the roof and leads to the left chimney. At the right, adjoining the house, are an ell and two sheds.

Pencil
16¼ × 21⅞ inches
Date: Summer 1948

The drawing is a preliminary study for the farmhouse which appears at the upper right of the painting, *Christina's World*, Museum of Modern Art, New York (see number 3). Wyeth has told how he came to do the painting. Here, even without the figure, one feels the mood of loneliness which is really the subject of the picture.

LENT BY MRS. ANDREW WYETH

5 WINTER CORN ILLUSTRATED

At the left, a dry cornstalk with a cob of corn, its yellow kernels visible beneath its dry, curled husk, dangles from the stalk. Behind it a partial view of the winter field with other stalks still standing on their hillocks. At the right, a single tall stalk with a bent top and a single hanging ear of corn; two smaller stalks with their dried tassel tops behind it to the left.

Dry brush drawing in tones of gray, brown, yellow, and red
31 × 40½ inches
Signed in ink at lower right: Andrew Wyeth
Date: Autumn 1948
Exhibitions: *Paintings and Drawings by Andrew Wyeth*, Currier Gallery, Manchester, New Hampshire, and the William Farnsworth Art Museum, Rockland, Maine, 1957, no. 67; *Andrew Wyeth*, Massachusetts Institute of Technology, Cambridge, Massachusetts, 1960, no. 13

LENT BY DR. AND MRS. HENRY SALTONSTALL

6 HANS HERR'S HOUSE ILLUSTRATED

A pen and ink sketch, on letter paper, of an old stone house on a slight elevation with an indication of grass surrounding it and clouds above. Another sketch on another letter page of a large stone fireplace with an iron kettle hanging from a crane in the center.

Pen and ink
10½ × 7¼ inches: house
10¼ × 7¼ inches: fireplace
Date: Winter 1948

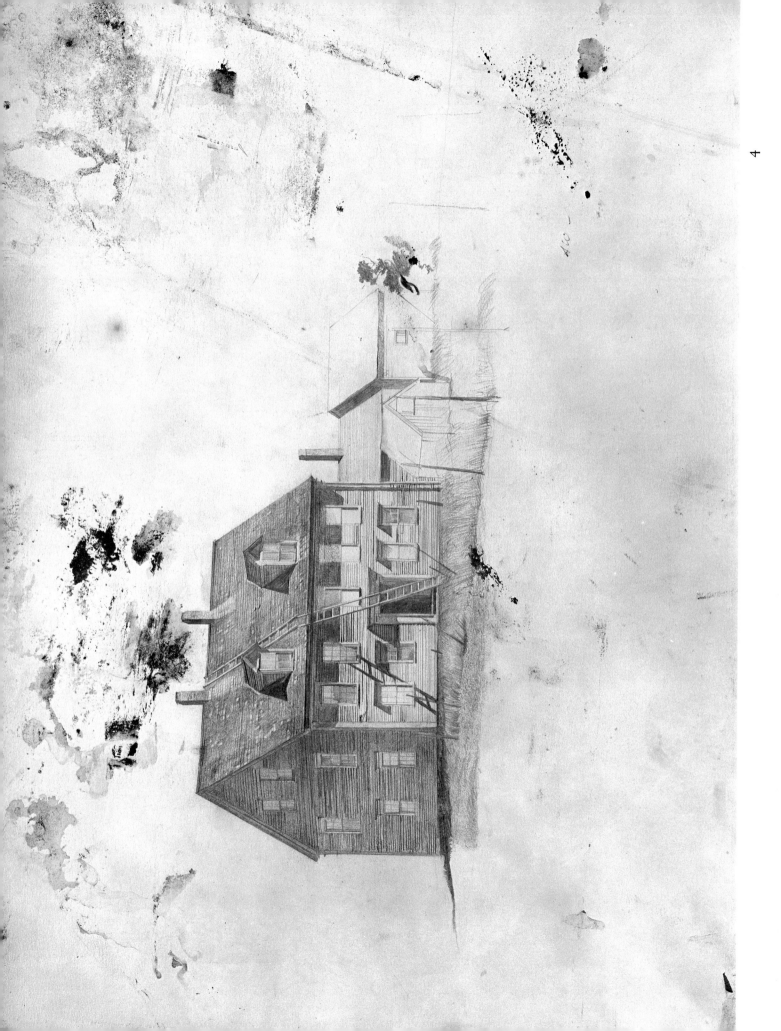

4

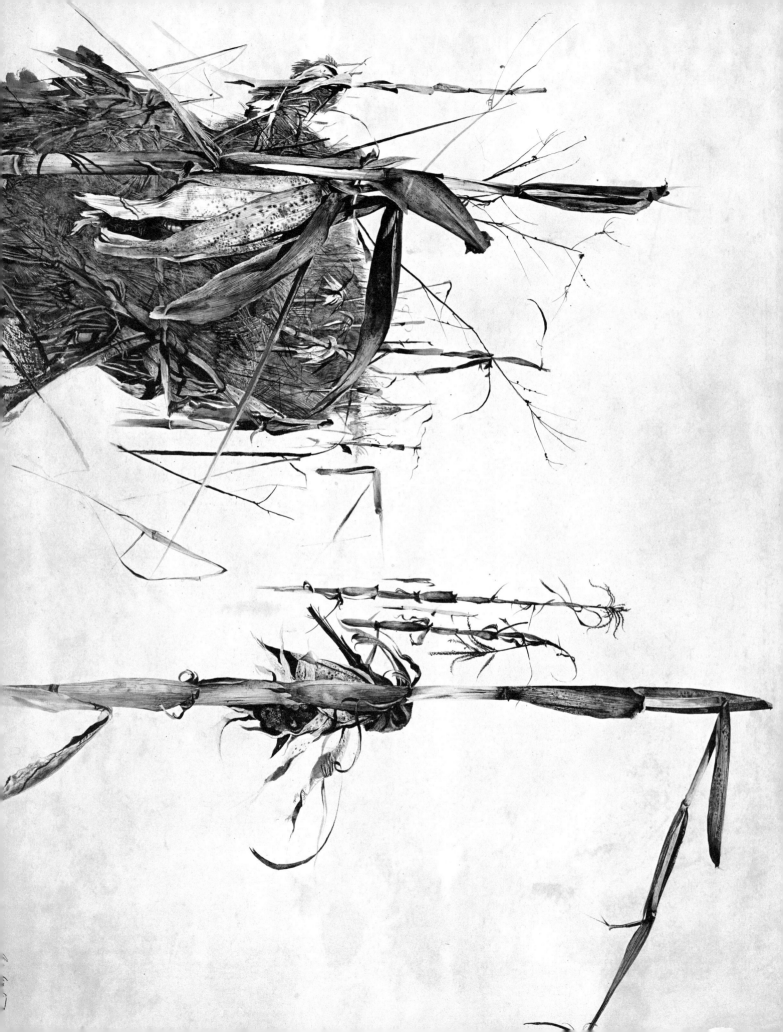

CHADDS FORD
PENNSYLVANIA

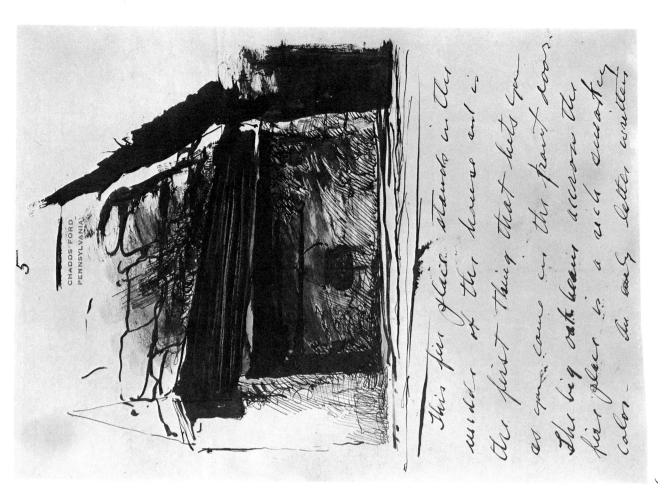

141 —
But what I showed it to
here is a rough sketch
of how things this way of
looks — little
color —
Pennsylvania
brick red

little old window

open country

The building was
built on a rock
foundation which
makes the building
seem as if its part
of the earth —
The stone wall
trembles right out
of the earth and the

This fire place stands in the
middle of the house and is
the first thing that hits you
as you come in the front door.
The big oak beam across the
fire place is a rich rusty
color — the oak letter written

In the winter of 1948 Wyeth was taken by his aunt, Mrs. Ralph Sargent, to the Christian Herr house, built by an early forebear of his mother's, on the outskirts of Lancaster, Pennsylvania. The house made such a profound impression upon him that he returned the following winter and did several watercolors of both the interior and the exterior. Indeed, the house seems to represent to the artist all the stone houses of Pennsylvania. The artist has always called the house the "Hans Herr House." Like numbers 11 and 21, these sketches are incorporated in an undated letter written by the artist to Mr. and Mrs. W. E. Phelps after one or the other of the visits to Lancaster:

"Bill and Mary, I have found the most wonderful house near Lancaster, Pa. that will just send you crazy. It was built in 1713 by Mr. Hans-Herr, a distant relation of my mother's. And what a house it is. Here is a rough sketch of something the way it looks—the building was built on a rock formation which makes the building seem as if it's part of the earth—

"The stone wall breaks right out of the house and is the first fire place stands in the inside of the house and is the first thing that hits you as you come in the front door. The big oak beam across the fire place is a rich smokey color. An early letter written by Mr. Herr tells of his writing a letter in December 1740 with a snow storm raging outdoors. The only light is from this fire place—and he states in a very interesting way 'that the room was filled with Thirty Indians which made the room smell of bear grease which they rubbed themselves with to keep warm'—Can't you picture this wonderful scene."

7 MARGARET HANDY

A half-length figure, she stands with her back to the spectator.

Pencil
9⅛ × 10⅝ inches
Date: Winter 1949
Exhibition: Wilmington, Delaware, Society of the Fine Arts, 1957, no. 61

The drawing is a preparatory study for the figure of Dr. Handy in the tempera painting in her own collection, *Children's Doctor* (reproduced: *Art News*, vol. XLII, Mar. 1–14, 1943, p. 17). Dr. Handy, a close neighbor and valued friend of the Wyeths', and for many years the doctor for their children.

8 LIGHTNING ROD ILLUSTRATED

The sharply pointed rod, which pierces a small shining globe, is attached to the peak of a shingled roof. Sharp sunlight casts its shadow on the shingles at the left. Beyond is the curving shore of a rocky cove.

Pencil on white paper
22 × 14⅞ inches
Inscribed at the lower right by the artist: Sky and water quite down in key/small glint on lightning rod globe brightest/spot/roof down deep in key/A.W.
Date: August 1950

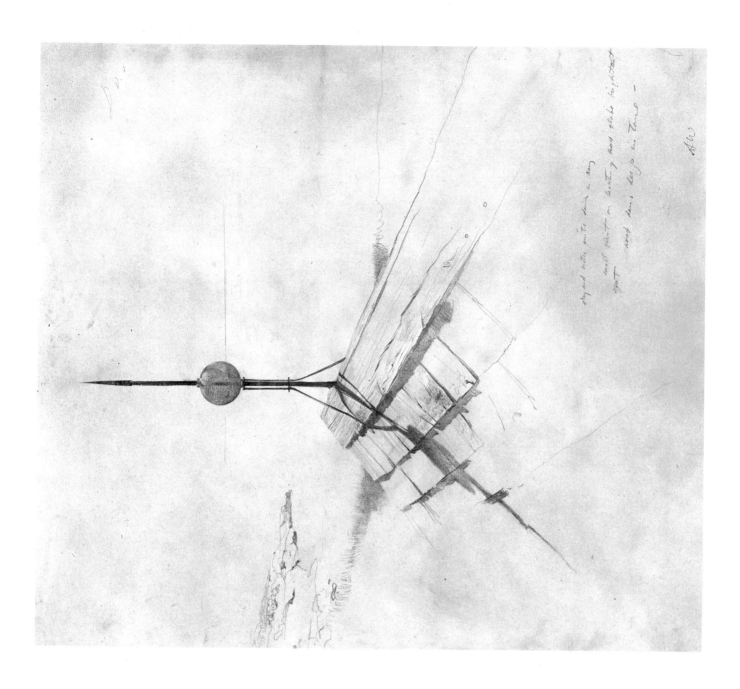

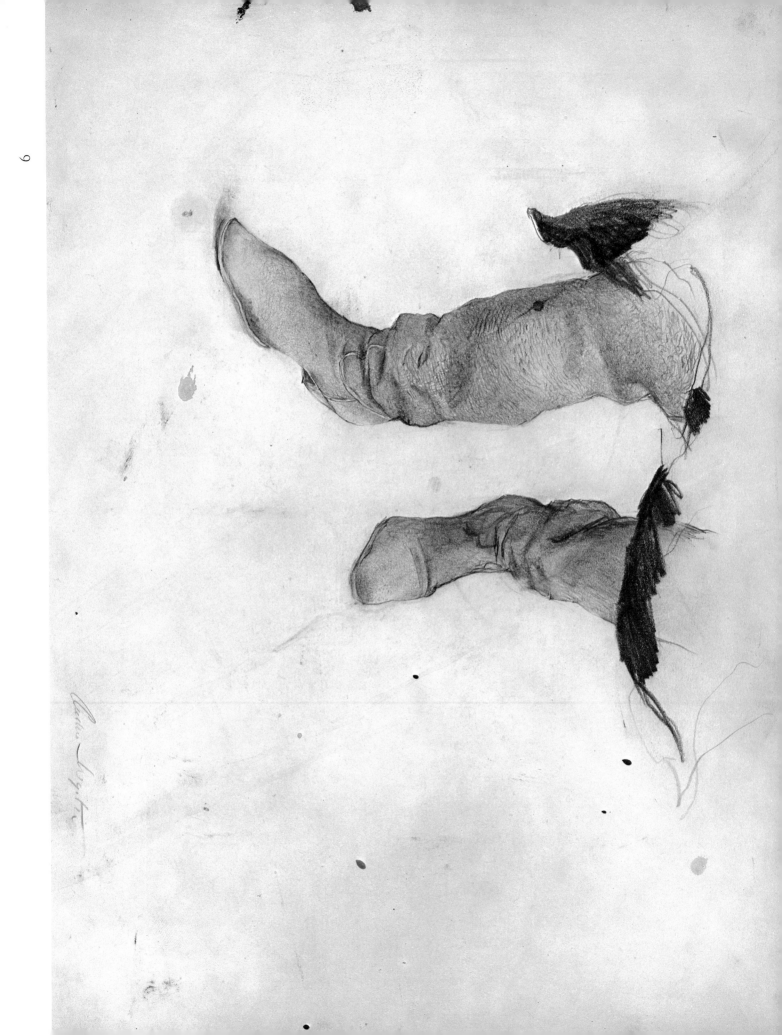

coonskin hat sent to him by the Phelpses, and which he wears also in the dry brush drawing, *Faraway*, number 11. A part of the letter is as follows:

"Jamie just came in the studio after being out on the hill sledding. He looked so perfect in your coon hat that I had to make this sketch for you. What a wonderful gift—nothing could please him more."

LENT BY MR. AND MRS. W. E. PHELPS

11 FARAWAY

ILLUSTRATED

With a dreamy expression on his face, a young boy sits on the slope of a hill surrounded by dried tampa grass and stalks of dried Queen Ann's lace with a leafless cherry sapling at the upper left and a pale sky showing at the upper edge. He wears a coonskin hat, a heavy child's navy coat, and his hands are clasped about faded blue dungarees, below which show old-fashioned soft leather boots with brass tipped toes.

Dry brush in pale greens, blues, tans, and browns
13⅝ × 20¾ inches (sight)
Signed in ink at lower right: Andrew Wyeth
Date: Early Spring 1952
Exhibitions: *Andrew Wyeth*, Macbeth Gallery, New York, November 6–29, 1952, no. 5; *Exhibition of Paintings by Andrew Wyeth*, M. Knoedler and Co., New York, October 26–November 14, 1953, no. 37; *Four Americans from the Real to the Abstract*, Contemporary Arts Museum, Houston, Texas, January 10–February 11, 1954, no. 9; *Third Annual Exhibition*, Museum of Art of Ogunquit, Maine, July 1–September 11, 1955, no. 13; reproduced; *Andrew Wyeth*, M. H. De Young Memorial Museum, San Francisco, California, July 12–August 12, 1956, and Santa Barbara Museum of Art, Santa

The drawing is a preliminary study for the tempera painting, *Northern Point*, Wadsworth Atheneum, Hartford, Connecticut, a painting which shows no more of Henry Teel's house than does the drawing, although in the painting the space at the right has been eliminated to make a more emphatic vertical composition (see *Ten Color Reproductions of Paintings by Andrew Wyeth*, Triton Press, New York, 1956, no. 2). The painting receives its name because the peak of the roof faces north. In the summer of 1950 the artist "climbed onto the roof of the two hundred year old Teel house to see the stretch of sea and islands beyond. The weathered decay of the black shingles in contrast to the smokey blue day and the amber light in the lightning rod excited me, so I painted *Northern Point* in the studio after making many pencil and water color studies on the spot." (Quoted *Wadsworth Atheneum Bulletin*, IInd series, no. 24, May–Sept. 1951, p. 2, painting reproduced same page). The lightning rod and globe appear again in numbers 21, 22, and 25.

LENT BY MR. AND MRS. PHILIP HOFER

9 BOOTS ILLUSTRATED

A figure, seen only from beneath the edge of a lightly indicated cloak which falls below the knees, advances toward the viewer. The soft, high boots, like those of a seventeenth-century cavalier, dominate the otherwise empty page.

Pencil on white paper
$10\frac{7}{16} \times 13\frac{3}{8}$ inches
Signed in pencil at lower right: Andrew Wyeth
Date: February 1951

The drawing is a preparatory study for the tempera painting, *Trodden Weed*, collection of Mrs. Andrew Wyeth (reproduced and discussed by Henry McBride, "All Quiet on the Whitney Front," *Art News*, Dec. 1951, p. 19 ff.). The boots are Wyeth's own, a Christmas present from his wife in 1950. They had belonged to Howard Pyle who had used them in his illustrations, but they fitted Andrew Wyeth and he wore them as he trudged about the Chadds Ford countryside convalescing from a very serious operation. In a letter to the editor of *Art News* (May 1952, p. 6), the artist tells how he came to draw and paint the boots.

LENT BY MRS. ANDREW WYETH

10 JAMIE ILLUSTRATED

A sketch on letter paper of a boy in a fur collared coat and a coonskin cap in profile to the left.

Pen and ink and watercolor
$10\frac{15}{16} \times 7\frac{1}{4}$ inches
Date: January 1952

This page is from a letter to the artist's good friends, Mr. and Mrs. W. E. Phelps, written just after Christmas of 1951. The sketch shows the artist's son, Jamie, wearing the

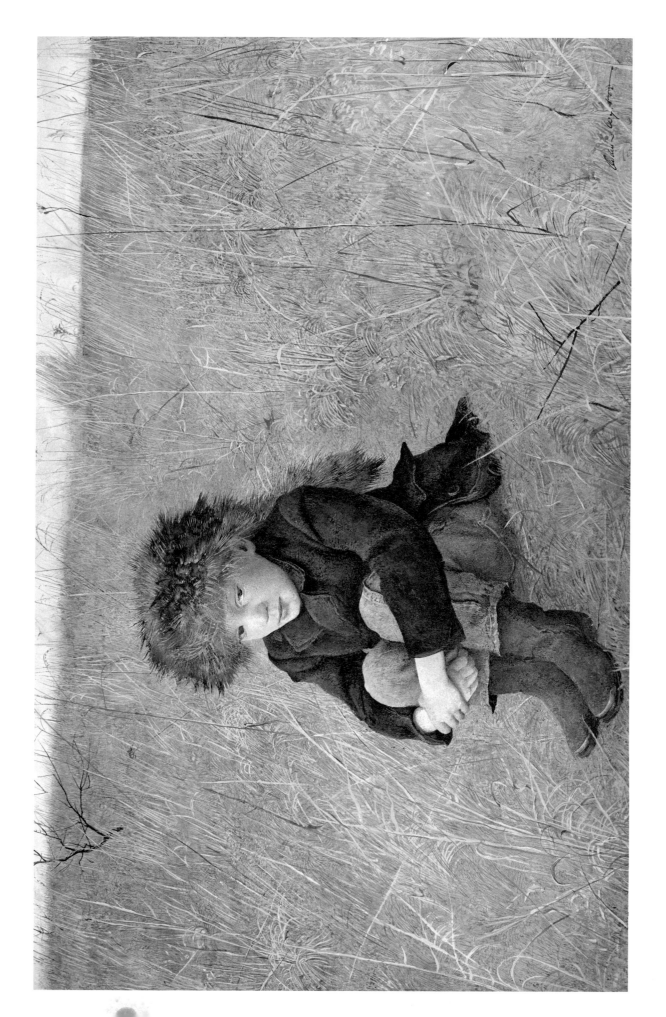

Jamie, the artist's younger son, had lost a small lead knight one day when out walking with his father. They retraced their steps to look for it, but without success. As he was walking back down the hill, the artist turned and saw his son sitting on the hillside, lost in his dreams. Jamie was wearing a Davy Crockett hat that had been given to him the Christmas before by the Wyeths' friend and neighbor, Mr. W. E. Phelps (see number 10). He was proud of his metal tipped shoes because he had been told they were of a kind worn by boys during the Civil War. The lost knight never turned up.

Barbara, California, August 28–September 23, 1956, no. 31; Five Painters of America, Worcester Art Museum, Worcester, Massachusetts, February 17–April 3, 1955; Wilmington, Delaware, Society of the Fine Arts, 1957, no. 51
Reproduced: Aline B. Louchheim, "Wyeth—Conservative Avant-Gardist," The New York Times Magazine, October 25, 1953, p. 28; Children's Book Section, The New York Times Book Review, November 14, 1954, p. 1; Lloyd Goodrich, "Andrew Wyeth," Art in America, October 1955, p. 20; Ten Color Reproductions of Paintings by Andrew Wyeth, Triton Press, New York, 1956, no. 5; Calendar of Events, January 8–February 7, 1957, The Wilmington Society of the Fine Arts, Delaware Art Center, on the cover
Mentioned: Gene Brackley, "Ogunquit: Andrew Wyeth," The Boston Sunday Globe, July 17, 1955

LENT BY MRS. ANDREW WYETH

12 MILK PAILS

Two milk pails of galvanized tin are placed side by side.

Pencil on white paper
5¼ × 5¾ inches (sight)
Date: November 1952

Exhibition: Wilmington, Delaware, Society of the Fine Arts, 1957, no. 60
The drawing is a preparatory study for the tempera painting Cooling Shed in the Collection of Mrs. Josiah Marvel, Greenville, Delaware. In the painting the pails are upside down on the stone rim of the spring trough (see Ten Color Reproductions of Paintings by Andrew Wyeth, Triton Press, New York, 1956, no. 9).

LENT BY MRS. ANDREW WYETH

13 ARCHIE'S CORNER ILLUSTRATED

In the left middle distance, lit by a pale winter light from the right, a small stone house, its roof gone, is falling to ruin. A row of bare trees and shrubs stretches out in a thin line across the middle of the page. Beyond it rises a bare hill, marked by a fence leading from the upper right over the brow of the hill in the middle. Bare trees, shrubs and fence posts are silhouetted against the sky and in the far distance is the curve of another hill.

Pencil on white paper
13¼ × 18¾ inches
Signed in pencil at the lower right: Andrew Wyeth
Date: January 1953

The drawing is a preparatory study for the tempera painting Snow Flurries in the Collection of Dr. Margaret Handy. The house held a particular fascination for the artist because when he was young it had been occupied by an old man who had an iron hook for an arm.

LENT BY DR. MARGARET I. HANDY

14 FLOCK OF CROWS

ILLUSTRATED

The hill is the same one represented in the preceding drawing (number 13), but here is seen closer up. The distant hill of the preceding drawing is here covered with snow. The flock of crows are flying and feeding on the hilltop at the right.

Dry brush in tones of brown and gray
9⁵⁄₁₆ × 19⅛ inches (sight)
Signed in pencil at lower right edge: Andrew W.
Date: January 1953
Exhibition: Wilmington, Delaware, Society of the Fine Arts, 1957, no. 59

Like number 13 this dry brush drawing is also a study for *Snow Flurries*. It was made a little later in the year when the snow had already begun to cover the distant hill.

LENT BY MRS. ANDREW WYETH

15 GEORGES RIVER PINES

ILLUSTRATED

A dense wood of pines and spruce, rising above the foreground sand-spit, is silhouetted against the sky, occupying three quarters of the page to the right. At the left, low on the horizon, is a strip of green and some smaller pine.

Dry brush in various greens and browns
9⅝ × 14¾ inches
Signed in crayon at the lower right: Andy Wyeth
Date: June 1953

This dry brush drawing is a preparatory study for the tempera painting *Sand Spit* in the Collection of Mr. and Mrs. Marcus Beebe of Blue Hill, Maine.

LENT BY DR. AND MRS. MYRON HOFER

16 SEA SHELLS

ILLUSTRATED

Various mussel shells and bits of seaweed are scattered across the page, just as they were seen on the sandy shore.

Dry brush in tones of black, blue, gray, and brown
1⅜ × 15⅜ inches (sight)
Signed in ink at lower right: Andrew Wyeth
Date: June 1953
Exhibition: Wilmington, Delaware, Society of the Fine Arts, 1957, no. 55

Like number 15 this also is a preparatory study for *Sand Spit* in the Collection of Mr. and Mrs. Marcus Beebe, Blue Hill, Maine. The artist was fascinated by the colors of the shells, which vary from an "almost Egyptian blue" to shiny black, and by their crisp, sharp edges.

LENT BY MRS. ANDREW WYETH

17 EAST FRIENDSHIP

In the middle distance, on the low ledges of a flat blueberry country, is the abandoned old meeting house, an echoing emptiness of sky and distance around it.

Pencil on white paper
1¼ × 15¾ inches (sight)
Inscribed in pencil at lower right: East Friendship Baptist/A.W.
Date: Summer 1953

This building is now destroyed.

LENT BY MRS. ANDREW WYETH

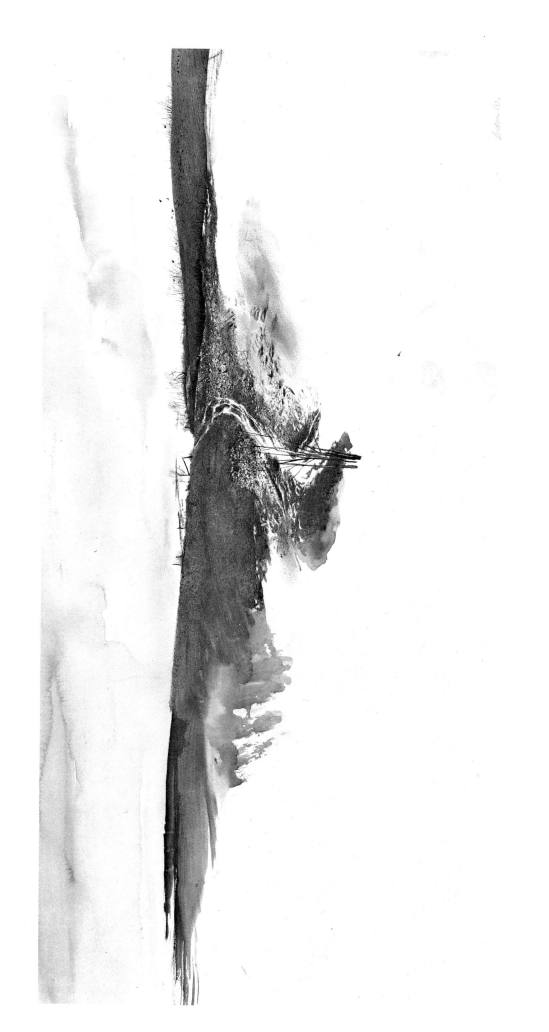

14

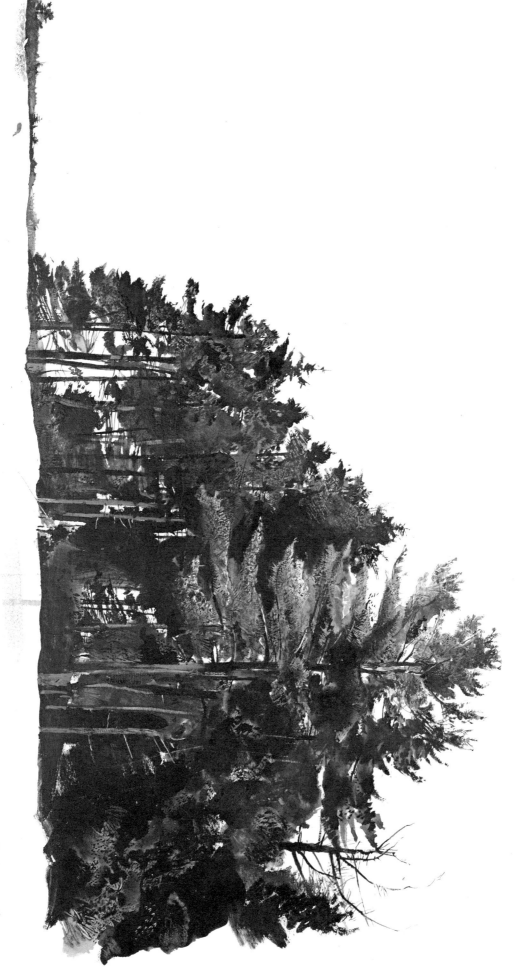

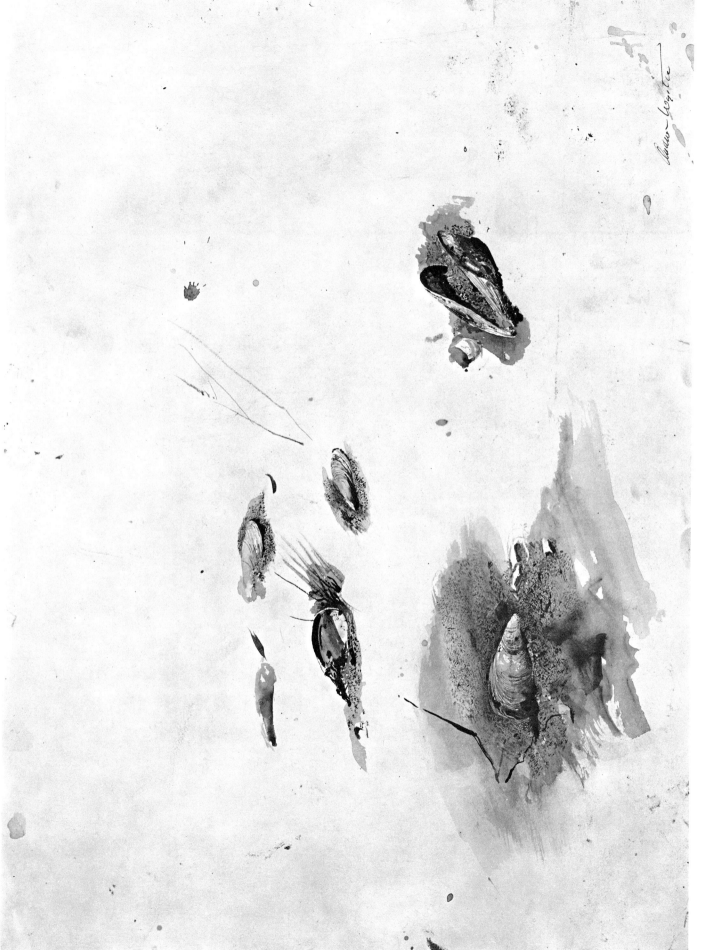

16

18 UNDER WATER

Looking down through clear water through which light plays, one sees a large buttonwood leaf lying on the bottom. Dark shadows cast by the light from the right emphasize its sharp edges. Small fish are swimming by in the upper center of the picture.

Pencil on white paper
13½ × 21½ inches (sight)
Date: Autumn 1953

The artist, who made this study at Chadds Ford, had a painting in mind at the time, but the interruption of a hunt and then a sudden flood, which changed the course of the brook, banished the original mood and the painting never evolved.

LENT BY MRS. ANDREW WYETH

19 CREEK BED

Like the preceding drawing, this one also is a view through water, alive with little minnows and their shadows and the buttonwood leaves lying on the stream's bottom.

Pencil on white paper
13⅝ × 20 inches (sight)
Date: Autumn 1953

See number 18.

LENT BY MRS. ANDREW WYETH

20 THE CORNER ILLUSTRATED

Looking down a snowy hillside one sees, nestling into the side of a hollow, a low white stone building with an octagonal roof, a chimney at the left and one at the right, a ladder lying at a careless angle on the roof at the left, bean poles stacked against the roof's edge further to the left. Behind the first building is a dark clapboard house with bare trees around it. Beyond, the ground rises to the snowy field's edge bounded near the top by fence posts. A gray winter sky hangs over the lonely landscape.

Dry brush in gray and brown with red accents in the brick chimney and a line of pinkish red brick at the edge of roof and wall
13½ × 21½ inches
Signed in pencil at the lower right: Andrew Wyeth
Date: December 1953
Exhibition: Wilmington, Delaware, Society of the Fine Arts, 1957, no. 49
Reproduced: Art in America, vol. L, no. 2, Summer, 1962, in color, p. 45

The building, now destroyed, was originally an octagonal Quaker schoolhouse. It was later taken over by the Negroes and became known as Mother Archie's Church, named for its beloved preacher. It had fallen into disuse when in 1945 the artist painted its interior, with cracked walls and ceiling, a broken lamp, and a flying pigeon (tempera, Mother Archie's, Addison Gallery of American Art, Andover, Massachusetts; reproduced: Art in America, vol. XLIII, Oct. 1955, p. 12). The hill beyond is the same hill shown in Flock of Crows, number 14 and Archie's Corner, number 13;

LENT BY MR. AND MRS. W. E. PHELPS

21 SKETCHES OF TEEL'S ISLAND ILLUSTRATED

Two quick sketches of the abandoned Teel house, one of a flatiron rigged on a rope serving as a lock for the kitchen door, and one of the kitchen and the black range.

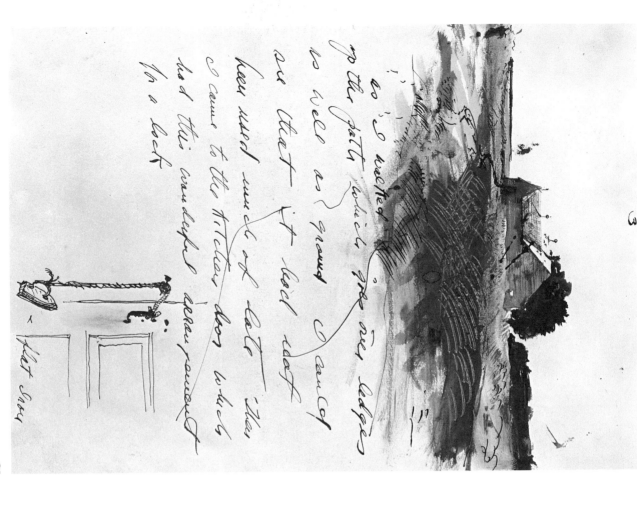

Pen and ink and watercolor
10⅜ × 7³⁄₁₆ inches
Date: June 19, 1954

Like numbers 6 and 10, these sketches also come from a letter from Andrew Wyeth to his friend, Mr. W. E. Phelps. This one, dated June 19, 1954, from Cushing, Maine, runs in part as follows:

" . . . This morning I took my boat and went down the Georges' River to Teel's Island. It was one of those beautiful clear Maine spring days with a light breeze blowing from the West. As I approached the island I noticed that Henry was still living at Port Clyde. He has been ill this winter and is still feeling weak from his illness. The island was alone . . . the only sound as I landed on the beach was the breaking of the water from the wake of my boat. I could see the Teel house just above the grass at the edge of the beach. As I walked up the path which goes over ledges as well as ground I could see that it had not been used much of late. Then I came to the kitchen door which had this wonderful arrangement for a lock. First view of kitchen as I opened the door (under kitchen sketch). The smell of this house is all of New England to me . . . the blue of this wood box and the black wood stove. I have plans to spend a lot of time on this island this summer."

22 TEEL'S HOUSE

The house is seen at an angle across a field, the lightning rod (number 8) at the upper right. There is a quick sketch of a crab in the left foreground.

Pencil
16 × 23 inches (sight)
Date: July 1954

Henry Teel, because of ill health, had been removed to the mainland. But in the summer of 1954 the artist returned to the island to sketch the abandoned house which had belonged to the Teel family for two centuries (see also numbers 8, 21, 23, 24, and 25). In 1945 Wyeth had painted a portrait of Henry Teel dressed in his workaday clothes, a cap on his head, seated in his spare kitchen, resting his left arm on the sill of an open window through which the clear light falls (*Henry Teel*, Collection of Paul E. Geier, Rome, Italy; reproduced: *Catalogue of Paintings and Drawings by Andrew Wyeth*, Currier Gallery, Manchester, New Hampshire, and Farnsworth Art Museum, Rockland, Maine, Summer 1951, no. 7). Henry Teel died in the spring of 1955.

LENT BY MRS. ANDREW WYETH

23 KITCHEN ELL

The ell is the ell of Henry Teel's house.

Dry brush in dark tones
14 × 18 inches (sight)
Date: July 1954

This drawing was accidentally cut shortly after it was done, but was pasted together again. The drawing was made on the same visit to Teel's Island as that mentioned in number 22.

LENT BY MRS. ANDREW WYETH

24 OAR

The abandoned oar, its leather hand guard worn and frayed, lies on the sloping shore of Teel's Island; around it, empty crab shells.

Lithographic crayon
14½ × 23 inches (sight)
Date: July 1954

A drawing of the dory to which this oar belonged is in the Currier Gallery, Manchester, New Hampshire. The Currier drawing is a preparatory study for the tempera painting *Spindrift*, also owned by the Currier Gallery. (Tempera reproduced: *Catalogue of Paintings and Drawings by Andrew Wyeth*, Currier Gallery and Farnsworth Art Museum, Summer 1951, no. 29). Like the previous drawings (numbers 22 and 23) this one was also made on Wyeth's visit to the island during Henry Teel's illness.

LENT BY MRS. ANDREW WYETH

25 TEEL'S ISLAND ILLUSTRATED

A weather-beaten skiff, its painter wound around the forward thwart, is pulled up on the dry grass in the foreground. Beyond it over the brow of the slight rise, nestling between rocks and bushes, is Henry Teel's house, its lightning rod and thin central chimney silhouetted against the pale sky.

Dry brush in browns, russets, dull reds, soft greens, and gray
9¾ × 22⅔ inches
Signed in ink at the lower left
Date: September 1954

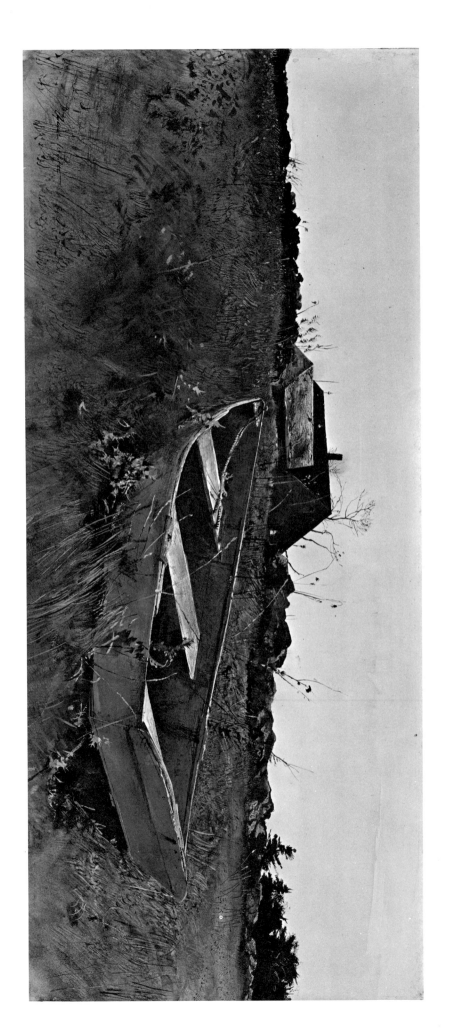

Exhibition: M. Knoedler and Company, New York, 1958, no. 38
Reproduced: Art in America, vol. L, no. 2, Summer 1962, reproduced in color, p. 41

The drawing gives the impression of the clear, dry, sparkling air of an early Maine autumn, which brightens the scenes and sharpens all edges. The skiff was always tied at the wharf, or at the boat mooring, if Henry Teel was out hauling his lobster traps. Because of his illness, it had been pulled up above high water. By autumn Wyeth realized Henry would probably never use it again and so did this poignant dry brush.

LENT BY MR. AND MRS. ROBERT MONTGOMERY

26 NORTH STAR BARN

The barn, a large one of native stone, is shown in early morning light. A stone wall crosses the foreground. Domestic geese are walking away from the barn. Snow covers the ground and the roof of the barn.

Dry brush
15 × 22¾ inches (sight)
Date: December 1954

This is the first dry brush done by Wyeth in the state of Delaware.

LENT BY MR. AND MRS. HAROLD S. SCHUTT, JR.

27 CORN

A study of the dry stalks with their dried tassels, of the corn husks and of seed pods.

Pencil
13½ × 20½ inches (sight)
Date: Autumn 1955

LENT BY MRS. ANDREW WYETH

28 PREPARATORY STUDY FOR "ROASTED CHESTNUTS"

A young man stands near his improvised chestnut brazier looking attentively towards the highway at the right.

Watercolor
13½ × 8½ inches (sight)
Inscribed in ink in artist's hand: "First color sketch"
Date: November 1955
Reproduced: Horizon, vol. 1, Sept. 1958, in color, p. 112.

This watercolor and numbers 29, 30, 31, 32, and 33 are all preparatory studies for the tempera painting Roasted Chestnuts in the Collection of Mr. and Mrs. Harry G. Haskell, Jr., Wilmington, Delaware (reproduced in color: American Artist, vol. xxii, Nov. 1958, p. 31). Wyeth began the preparatory drawings by November 1, 1955 and the tempera was completed by April 17, 1956. He went up to the road where the young man was selling roasted chestnuts and made many studies of the figure, the oil can, and even the bushes in the background. This watercolor, which the artist himself later inscribed, was very closely followed in the finished tempera; indeed, it has the same proportions as the finished picture.

LENT BY MR. AND MRS. HARRY G. HASKELL, JR.

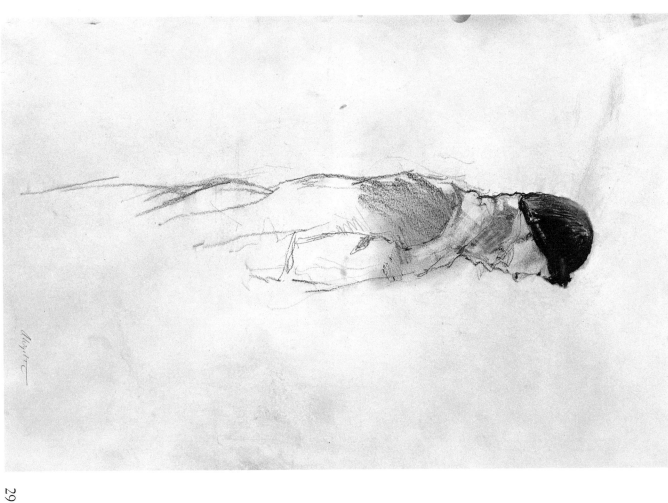

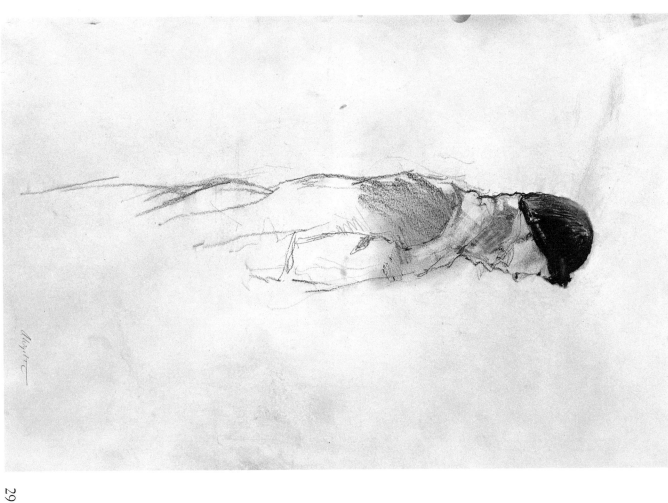

29 BOY STANDING

A half-length study of a young man in an old sergeant's jacket and black stocking cap in profile to the right.

Charcoal
22¼ × 13¾₆ inches
Date: November 1955

This charcoal drawing is another preparatory study for the tempera painting *Roasted Chestnuts*.

LENT BY MRS. ANDREW WYETH

30 PREPARATORY STUDY FOR "ROASTED CHESTNUTS"

The mason jar at the lower right was omitted in the tempera. The sergeant's stripes are still visible on the sleeve of the old army jacket which the youth wears.

Pencil
11 × 8¾ inches (sight)
Signed in pencil at lower left: A. Wyeth
Date: November 1955

LENT BY MR. AND MRS. HARRY G. HASKELL, JR.

31 PREPARATORY STUDY FOR "ROASTED CHESTNUTS"

A detailed study of the empty, rusty oil drum and the aluminum basin fitted into its top which had been made into a charcoal brazier, standing in a late afternoon light, its long

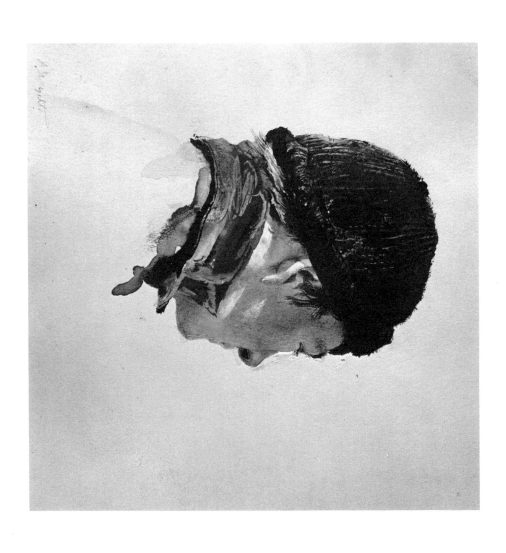

shadow falling to the right of it across the few tracks along the edge of the road.

Pencil
10⅜ × 14½ inches
Signed in pencil at lower right: A.W.
Date: November 1955

LENT BY MR. AND MRS. HARRY G. HASKELL, JR.

32 OSAGE ORANGE: PREPARATORY STUDY
FOR "ROASTED CHESTNUTS"

Bare branches of an Osage orange bush.

Pencil
14½ × 10½ inches (sight)
Date: November 1955

In the tempera painting, the young man stands in front of a tangle of bare branches. The artist felt it was important to know the structure and texture of the bush, for its upper bare branches are silhouetted against the sky.

LENT BY MR. AND MRS. HARRY G. HASKELL, JR.

33 ALLAN: PREPARATORY STUDY FOR
"ROASTED CHESTNUTS"
ILLUSTRATED

Head and collar of a young man in profile to the right.

Watercolor
4¹⁵⁄₁₆ × 4¹⁵⁄₁₆ inches. Reproduced actual size
Date: November 1955
Former Collection: Dr. Margaret I. Handy
Exhibition: Wilmington, Delaware, Society of the Fine Arts, 1957, no. 63

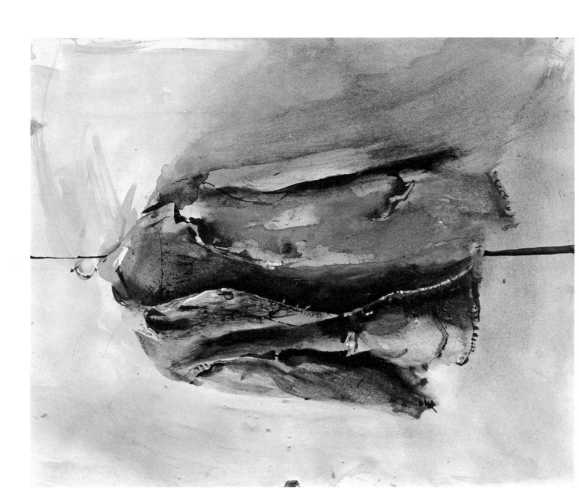

The watercolor shows just the head and collar of the young man, Allan Messersmith, the son of the local tinsmith of Chadds Ford. He is wearing a tight black stocking cap of the kind worn by sailors, and a double layer of emerald green collars, the collars of the two shirts which he wore for warmth under his old army jacket. Although he faces away from the light, his face is bright from the reflections from the snowy ground in front of him. The artist made many sketches of the eighteen-year-old youth as he stood by the side of the West Chester Road in the bitter cold of an early winter twilight.

LENT BY MRS. ANDREW WYETH

34 HORACE'S COAT

Pencil
11¼ × 8¼ inches (sight)
Date: January 1956

This pencil study preceded the brush drawing, number 35.

LENT BY MRS. ANDREW WYETH

35 BLUE COAT

ILLUSTRATED

The worn, faded blue jacket hangs on a wooden hanger suspended from a simple nail in the white wall.

Dry brush
13⅝ × 10¹³⁄₁₆ inches
Date: January 1956

The coat belonged to a neighbor, Horace Kipe, a retired engineer of the Pennsylvania Railroad. He had a service station

and then a farm and used to pass by the Wyeths' carrying straw to his mule, wearing this worn and battered jacket. The artist wished to paint Horace's portrait, but death intervened. Wyeth then borrowed the coat from Horace Kipe's widow and hanging it on his own studio wall made this dry brush drawing. The warm material, the handsome quality of the blue, the soft folds, the brass buttons—and the associations with the man to whom it belonged—all appealed to him. Number 34, a pencil study, preceded this dry brush drawing.

LENT BY MRS. ANDREW WYETH

36 THE BED ILLUSTRATED

Pencil
13 5/16 × 19 15/16 inches (sight)
Date: June 1956
Exhibition: Wilmington, Delaware, Society of the Fine Arts, 1957, no. 62
Reproduced: Time, vol. 69 (Jan. 7, 1957), in color, p. 61.

The covers are thrown back towards the foot of a handsome four-poster bed. Near the pillows at the head of the bed is a basket filled with books and an empty eyeglass case. On the floor to the right of the post near the center of the page is a large sea shell.

The drawing is a preparatory study for the tempera painting Chambered Nautilus in the Collection of Mr. and Mrs. Robert Montgomery, New York (reproduced: Alexander Eliot, Three Hundred Years of American Painting, New York, 1957, pp. 388-389). The drawings were begun November 11, 1956, and the tempera was completed May 15, 1957. The in Maine by June 15, 1956, the summer of Mrs. Wyeth's mother's last illness. The tempera painting was completed September 18, 1956. From the bed the invalid looked out to sea and the bright sea air filled her room. Near her she kept a basket with her Bible and the other books she was reading. In the tempera (reproduced: The Studio, vol. CLVII, Apr. 1959, p. 121) the view of the bed has been changed, the invalid sits up in bed, arms clasped around knees, looking out to sea. A wind stirs the net bed curtains and the shell, changed to a chambered nautilus, rests on a chest at the foot of the bed.

LENT BY MRS. ANDREW WYETH

37 FARM POND

Watercolor
13 1/4 × 21 1/2 inches
Date: November 1956
Exhibitions: M. Knoedler and Company, New York, 1958, no. 16; Massachusetts Institute of Technology, Cambridge, Mass., 1960, no. 33
Reproduced: Art News, vol. 57, Dec. 1958, p. 13.

A narrow, dark pond in the foreground with fresh snow around it, a hill rising behind it to the right, a bare sapling in the middle distance. On the left above the pond is the farmhouse.

The watercolor is a preparatory study for the tempera Brown Swiss in the Collection of Mr. and Mrs. Alexander Laughlin, Locust Valley, New York (reproduced: The 1958 Pittsburgh Bicentennial International Exhibition of Contemporary Painting and Sculpture, Carnegie Institute, Pl. 8, no. 483). The drawings were begun November 11, 1956, and the tempera was completed May 15, 1957. The

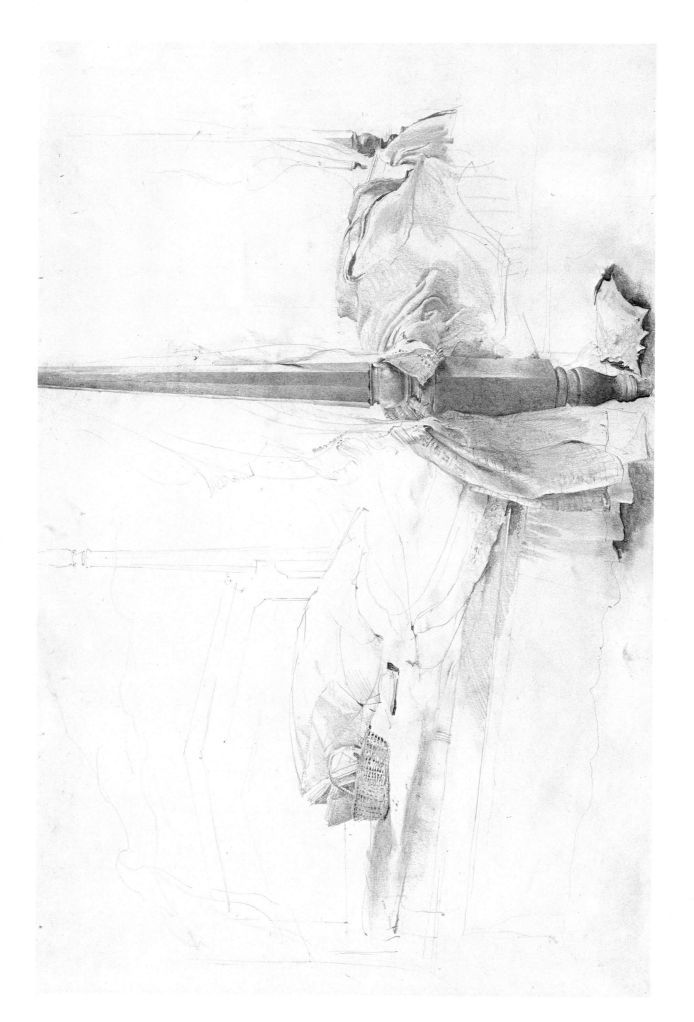

artist, driving his jeep home in the winter twilight, turned and saw the dark pond surrounded by a fresh fall of snow. The water in the pond was still and gleaming, not yet frozen. He sketched the scene quickly in watercolor, to catch the damp, liquid quality of the water and the new snow before the light faded. In the tempera there is no snow. This drawing was actually done from the bottom of Kuerner's Hill (number 2) looking across the road down onto the pond with Karl Kuerner's house looming above and reflected in the still water. The tempera painting is called *Brown Swiss* because that is the kind of cattle Kuerner owns and it is their tracks that mark the earth. The house is the same house that appears in *Young Bull*, number 67, and the study, number 64.

LENT BY MRS. FREDERICK H. LASSITER

38 ROPE AND CHAINS ILLUSTRATED

The rope and chains are looped around the bare branches of a tree.

Pencil
17⅞ × 23½ inches (sight)
Date: November 1956

Like number 37, this also is a preparatory study for *Brown Swiss*, Collection of Mr. and Mrs. Alexander Laughlin, Locust Valley, New York. This detail appears at the extreme left of the tempera near the corner of the house. The chains are those which Karl Kuerner uses when he slaughters his pigs. Another drawing of the same branch with chains is in the Collection of Mr. and Mrs. W. E. Phelps, Montchanin,

Delaware. A letter of January 27, 1957, from the artist to Mr. Phelps reads in part as follows:

"Things are at long last getting quiet again and I have been taking long walks over the winter hills. Just this morning I went over to Karl Kuerner's house . . . and as I walked up the lane by the house and toward the barn I noticed the rope and chain used for hanging the pig when Karl and his son butchered it a number of weeks ago. I thought of you, Bill, and how you would have been thrilled by this sight. "This is my time of year now and I spend all my time out in it. How I wish I could really get this down in paint."

LENT BY MRS. ANDREW WYETH

39 PETER HURD

The drawing shows just the head and an indication of the collar, the head facing in profile to the right.

Pencil
11 × 8¼ inches (sight)
Date: January 1957

The drawing is a portrait of Mr. Wyeth's brother-in-law, the artist Peter Hurd.

LENT BY MRS. ANDREW WYETH

40 HOUND

The hound sits, chained, near the door of the mill.

Dry drush
14¾ × 22½ inches (sight)
Date: Autumn 1957

Reproduced: *The Studio*, December 1960, p. 206, in color

Henry C. Pitz, in an article, "Andrew Wyeth" (*American Artist*, vol. xxii, Nov. 1958, pp. 27–29) reproduces three pencil sketches, one watercolor, and the tempera *Raccoon*. The artist was fascinated by the sad, damp-eyed hound sitting with such a thoughtful expression near the mill. The tempera painting, which was completed May 15, 1958, is in the Collection of Mr. and Mrs. Harry G. Haskell, Jr., Wilmington, Delaware. The preparatory drawings were begun October 15, 1957.

LENT BY MRS. ANDREW WYETH

41 BLUE TICK

Two sketches of heads at lower left and middle right, a sketch of a body just left of center. At upper right another dog.

Pencil

13 × 20 inches (sight)

Inscribed with color notes: blue black with ? brown towards nose Brown spot/running into black

Date: November 1957

Like number 40, this also is a preparatory study for *Raccoon*, although in the painting one sees only the body and hind quarters of the dog at the lower edge of the painting. *Blue Tick* is the name by which a hound with the coloring of this dog is known.

LENT BY MRS. ANDREW WYETH

42 CHAIN RING

Three detailed studies of the chain which holds the hound, the one at the left in pencil, the center one in dry brush in tones of brown and gold, the one at the right a shiny, silvery chain and ring.

Dry brush and pencil

13 × 19½ inches (sight)

Date: November 1957

LENT BY MRS. ANDREW WYETH

Like numbers 40 and 41, a preparatory study for *Raccoon*.

43 ALVARO'S HAYRACK ILLUSTRATED

The empty hayrack stands in the center middle distance near the shore, in brownish and olive green grass. Beyond it, under a silver gray sky, gleams the calm water of the mouth of the Georges River. A fog is drifting in from the sea at the right over the blue and slate-blue mass of Little Caldwell Island in the background.

Dry brush

8½ × 22¼ inches

Signed in blue ink at lower right: Andrew Wyeth

Date: September 1958

Every year, after the hay is in, Alvaro, Christina Olson's brother (see number 3), leaves the hayrack to weather near the water.

LENT BY THE WILLIAM A. FARNSWORTH LIBRARY AND ART MUSEUM

43

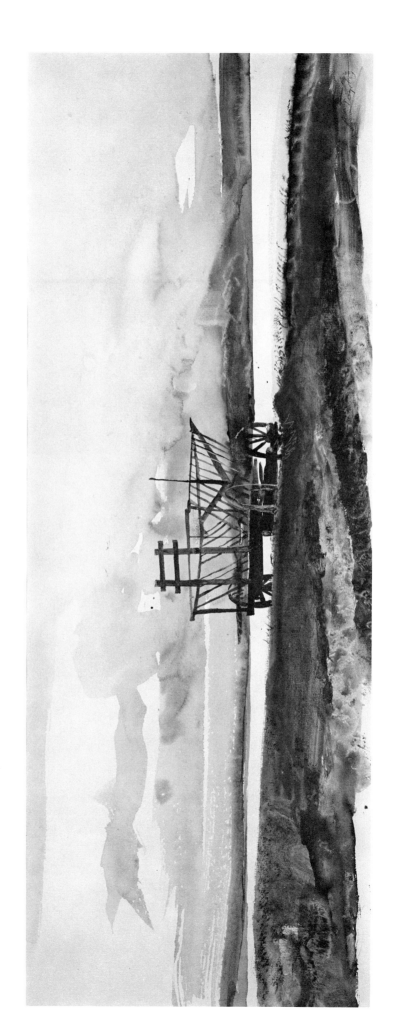

44 THE SLIP

ILLUSTRATED

The two-masted Chesapeake Bay "Bug-eye," pulled up for the winter in a slip at Rockland, looks as though it were afloat on a sea of tawny grass. The foresail is furled, and its halyards are still taut. The jibs and mainsail have been removed. There is a narrow light blue line near the gunwale and a feeling of gold under the bowsprit. A fog is drifting in from the right and beginning to blur the view of the long, low, gray sail loft in the background.

Dry brush
20¾ × 29 inches (uneven across the bottom)
Signed in black ink at lower right: Andrew Wyeth
Date: Begun June 1958; set aside and completed September 1958
Exhibition: M. Knoedler and Company, New York, 1958, no. 44

The raking angle of the masts and the slight curve in the second mast appealed particularly to the artist.

LENT BY MRS. ANDREW WYETH

45 GERMAN SHEPHERD

ILLUSTRATED

At the lower left a German shepherd dog lies asleep in the sunlight coming through the window in the right background.

Pencil
23½ × 17 inches (sight)
Date: January 1959

The drawing is a preliminary study for the tempera painting Ground Hog Day, Philadelphia Museum of Art (reproduced: Studio, vol. 160, Dec. 1960, p. 209; in color: Horizon, vol. IV, no. 1, p. 92). In the painting the dog has been eliminated and a white kitchen table, set with a knife, simple white plate, and cup and saucer moved into the corner in front of the window. The scene is in the kitchen of the Karl Kuerner farm.

LENT BY MRS. ANDREW WYETH

46 PREPARATORY STUDY FOR "GROUND HOG DAY"

The wall and window of the previous drawing, but here the angle of the viewer has changed and there are lemons and oranges on the window sill.

Dry brush and pencil
22⅜ × 17 inches (sight)
Date: January or February 1959

Like number 45, this also is a preparatory drawing for Ground Hog Day. The kitchen is that of the house shown in the background of numbers 37 and 67, Karl Kuerner's farm. The cracked pane at the upper left remains in the painting, but the fruit disappears; the snow in the background has melted, but the wire fence beyond the window remains and the light and shadows cast through the window on the wall at the left.

LENT BY MRS. ANDREW WYETH

47 ADAM

ILLUSTRATED

A close-up view in profile toward the right of the head of a Negro.

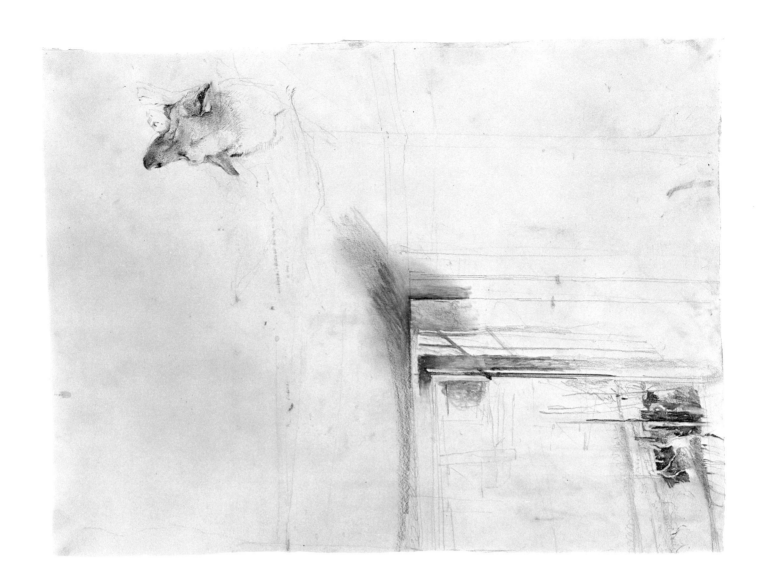

45

Pencil
13⅞ × 21½ inches (sight)
Date: January 1959

Adam Johnson, an elderly Negro, is a neighbor of the Wyeths' who works around the place in Chadds Ford. The artist was interested in the shape of his head and the humor of his facial expression.

LENT BY MRS. ANDREW WYETH

48 ETTA ILLUSTRATED

The head in profile to the left of a Negro woman, a braid falling down her left cheek.

Pencil
13⅞ × 21⅞ inches (sight)
Date: January 1959

Etta is Adam's wife (see number 47).

LENT BY MRS. ANDREW WYETH

49 NEGRO HAND ILLUSTRATED

A right hand, lying on the counterpane, the arm and reclining figure lightly indicated.

Pencil
13¾ × 21¾ inches (sight)
Date: January 1959

The hand is that of Tom Clark, the old Negro asleep in *Garret Room* (number 72).

LENT BY MRS. ANDREW WYETH

50 MARCH STORM ILLUSTRATED

From the dark interior of a barn, one looks through a half-opened barn door towards the storm which is filling the air with large flakes and piling heavy wet snow against the open door.

Dry brush
15¹⁵⁄₁₆ × 10¹³⁄₁₆ inches
Date: March 1959

As a boy, the artist used to rush to get his sled from the hay loft of the barn at the first snowfall. He remembered that early experience as he stood in the shadow of the barn and painted the dark, rich foreground of the barn and sought to emphasize the contrast with the cold, wet snow.

LENT BY MR. AND MRS. W. E. PHELPS

51 EGG SCALE ILLUSTRATED

On a table in the center, a box of the kind in which baby chicks are transported is filled with eggs. In front of the box is the delicate egg scale of a pale blue cast. Below at the left, two crates with eggs which have already been weighed. The pale color of the eggs contrasts with the warm brown of their surroundings.

Dry brush
14⅞ × 17⅞ inches
Date: June 1959

The scale is Alvaro Olson's (see *Alvaro's Hayrack*, number 43). The artist was intrigued by the fragile quality of the eggs' shells piled in the yellow box with its air-vents. The

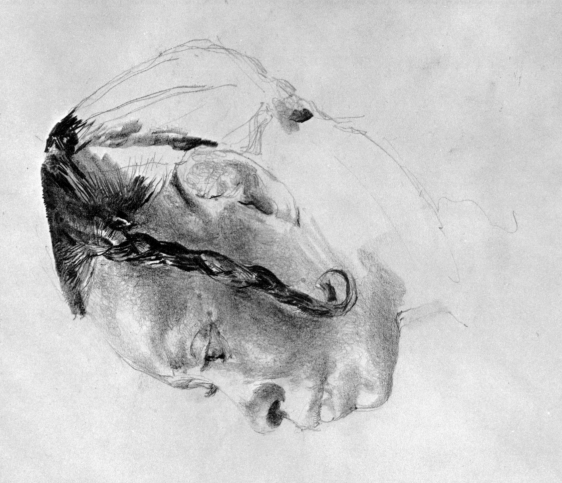

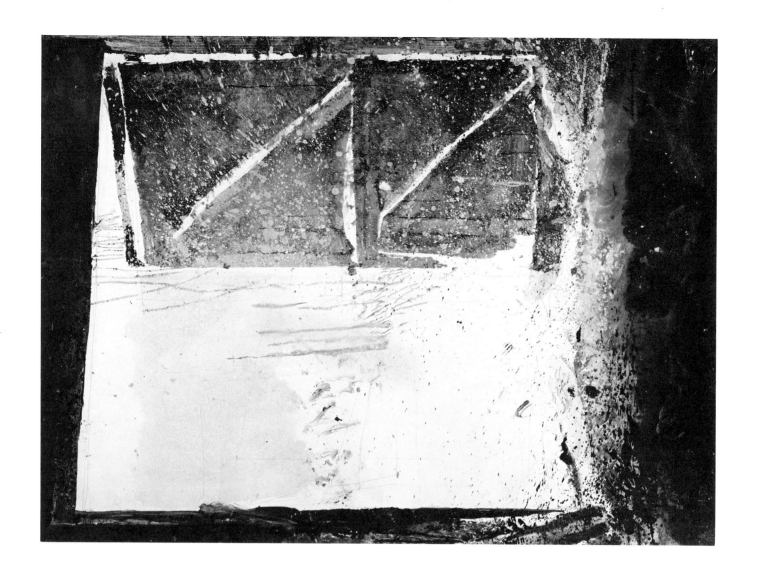

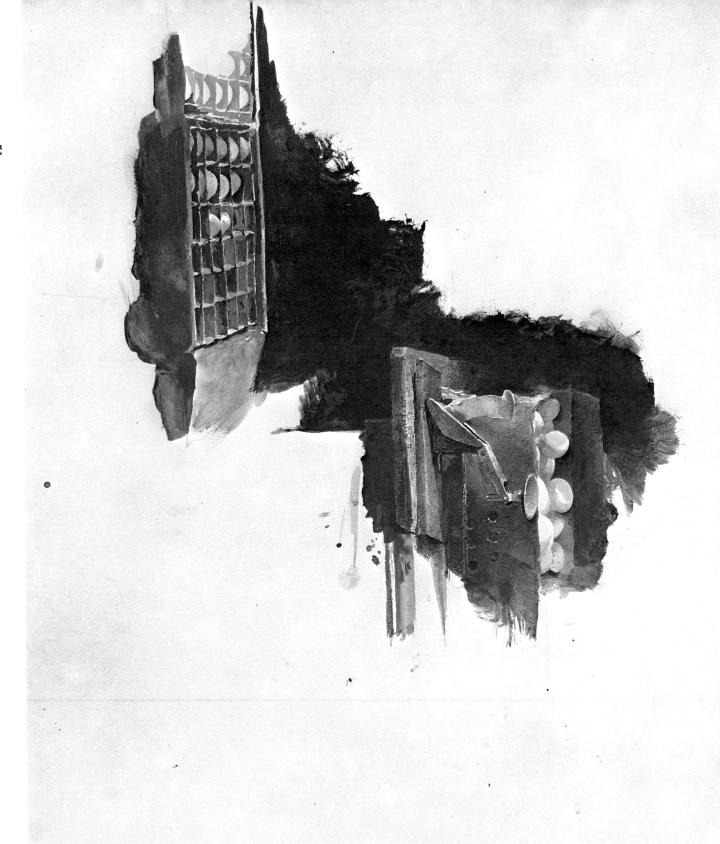

scene recalled to him a boyhood experience of watching his grandfather weigh eggs on a similar scale.

LENT BY MRS. ANDREW WYETH

52 BLUE MEASURE

Near the center lie some empty feed bags thrown over a low empty grayish barrel. Bits of straw cling to the bags. On top of them is a blue metal measure. The timbers of the barn are gray. Light comes in from the right at a sharp angle through a big, unseen, open door.

Dry brush
21½ × 15 inches (sight)
Date: August 1959

The barn is Alvaro Olson's (see numbers 43 and 51).

LENT BY MRS. ANDREW WYETH

53 BEE-HIVE

The bee-hive hangs from the branches of the beech tree, with a few bees coming and going and honeysuckle still around the comb.

Pencil
22½ × 12¾ inches (sight)
Date: October 1959

The hive is the same one drawn again in *Winter Bees* (number 54).

LENT BY MRS. ANDREW WYETH

54 WINTER BEES ILLUSTRATED

A bee's honeycomb, in tones from pale gold to deep brown, is suspended from the bare branches of a beech tree at the left. At the right is a detailed study of a section of the tree's trunk in tones from pale yellow to silver.

Dry brush on white paper
21 × 27 inches (sight)
Date: November 1959
Exhibition: Pennsylvania Academy of Fine Arts, 1960
Reproduced: *Art in America*, vol. L, no. 2, Summer 1962, in color, p. 39 (as *Storing Up*)

The pencil drawing, number 53, preceded this. By the time the artist drew this, most of the bees had gone into the comb. The shadows are those of late afternoon. When Wyeth returned from Maine in the autumn to discover this honeycomb in his mother's woods, a few bees were still buzzing around. As the days grew shorter and the nights colder, fewer and fewer bees appeared. Then suddenly the cold became bitter and a light snow fell. He wondered if his bees would be alive. All was quiet—not a bee. Then he held his ear close to the comb and sure enough a faint buzzing came from deep within. The drawing was never completed because a possum or some other animal got to the comb and ate up the honey!

LENT BY MRS. ANDREW WYETH

55 SLIPPERS ILLUSTRATED

A pair of worn men's slippers dominates the lower half of the page. Above, beneath a shelf, hangs a pair of scissors.

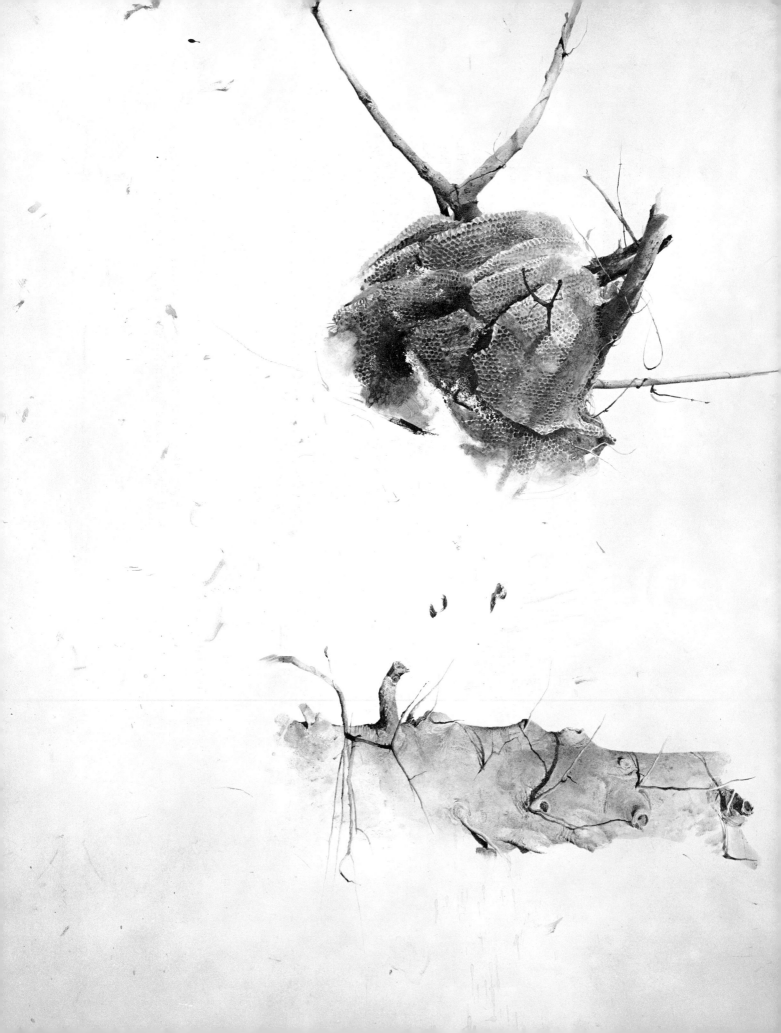

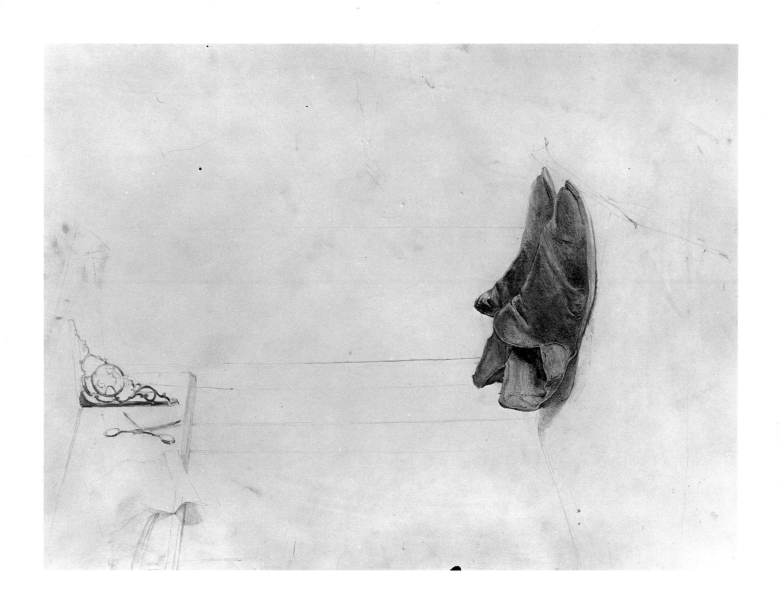

Pencil
21 15/16 × 13 15/16 inches (sight)
Signed in pencil at lower right: AW
Date: November 1959

The drawing is a preparatory study for the tempera painting *That Gentleman*, Dallas Museum of Fine Arts. Tom Clark (number 72) is "That Gentleman." Both slippers and scissors are included in the tempera painting, which was completed April 28, 1960, its preparatory drawings having been begun November 15, 1959.

56 MILL BUILDINGS ILLUSTRATED

In the middle distance, beyond a high fence of boards at the left and of slats at the right, stands a group of four buildings, two with pitched roofs, with a silo glimpsed between them at the left and a house at the right. The bare branches of trees rise above and beyond the roofs. A flock of pigeons flies above the silo. Others are perched on the peak of the mill's roof. A low winter light comes from the left.

Pencil
15 × 21 15/16 inches (sight)
Date: November 1959

57 THE MILL ILLUSTRATED (COVER)

The scene is the same as number 56, but viewed nearer to. The pigeons here are flying across the center.

Dry brush
13 7/8 × 22 5/16 inches
Date: December 1959

This is Brinton's Mill as it was when the Wyeths acquired it. The silo has now gone. The dry brush drawing was made in December from beyond the corral in the foreground in the late afternoon. The golden amber light, the damp, dark foreground, the deep shadows and the sudden flight of the pigeons in a straight line all appealed to the artist. The drawings 40, 41, and 42 were done in front of this mill before Wyeth bought it.

58 BELOW THE KITCHEN ILLUSTRATED

A ham and some bacon are hung from a nail in a beam. Below them, beneath an arch, dark shadow; at the right, their shadows cast by the light from the left.

Dry brush
22 1/4 × 17 1/2 inches (sight)
Signed at lower left: Andrew Wyeth
Date: March 1960

Karl Kuerner smokes his own ham and bacon and then hangs it in his cellar where the artist saw it. The moist, reddish ham, the fresh cut edges of the bacon, the leather thongs, the chimney arch in the cellar, the deep gold light striking the meat and the shadows it cast, the white wash peeling from the wooden beam, all fascinated the artist.

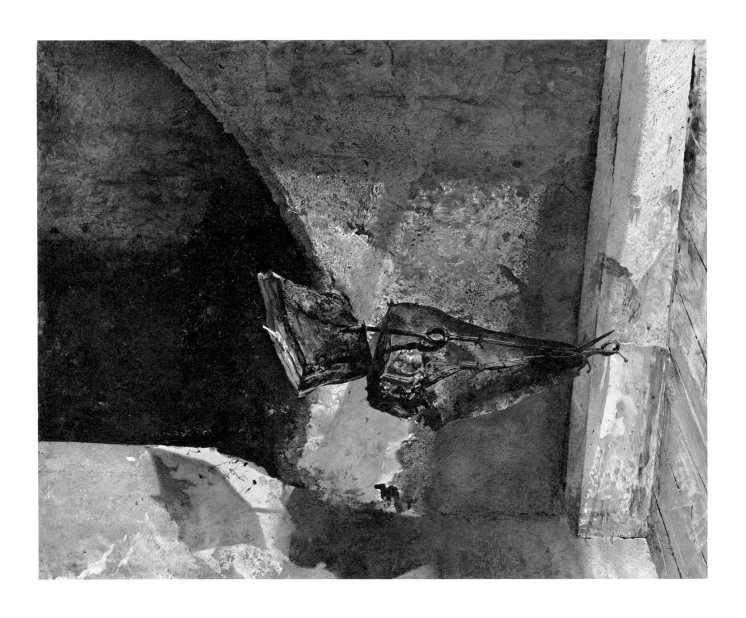

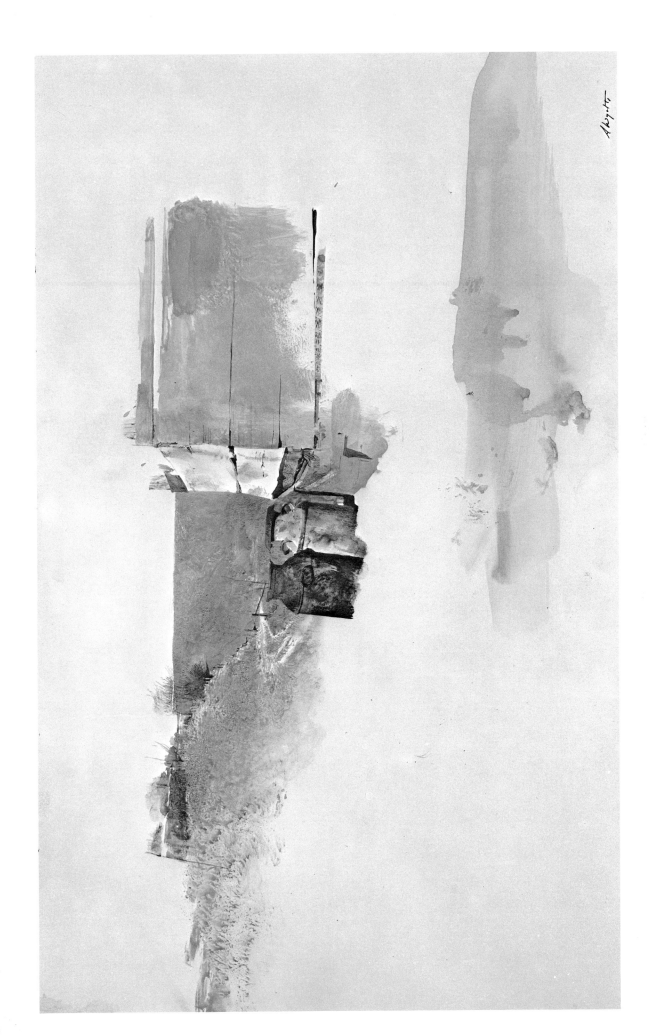

59 MILK CANS ILLUSTRATED

Two milk cans, one of dark metal, the other a pale silvery tone, stand side by side in the center, the broad boards of a pig pen to their right. Kuerner's hill rises behind them, with snow in the ruts of the curving tracks, the field honey-colored.

Dry brush
13 5/16 × 19 15/16 inches (sight)
Signed in ink at the lower right: A. Wyeth
Date: March 1960

The morning was a very cold one. The scene was one of harmonies of honey and silver. So that he would remember the clarity of the morning light on the hill, the artist tried a few washes in the right foreground.

LENT BY MRS. ANDREW WYETH

60 MAY DAY ILLUSTRATED

A line of Spring Beauties at the edge of a gray bank, beyond them the water of the mill's raceway.

Dry brush on white paper
12 3/4 × 29 inches (sight)
Date: May 1, 1960
Exhibitions: Pennsylvania Academy of Fine Arts, 1960; Massachusetts Institute of Technology, Cambridge, Mass., 1960, no. 40; Wilmington, Delaware, Society of the Fine Arts, 1961
Reproduced: Art in America, vol. L, no. 2, Summer 1962, on the cover in color

The picture has been cut down at the top to give it the present friezelike proportions. The silver maple and dried beech leaves were pushed aside in the spongy, wet spring earth by the Spring Beauties which blossomed near the dark water, some of them opening to the morning light as the artist, lying prone on his stomach, sketched their fragile, luminous shapes, delighted by the sparkle of their bright forms against the damp wetness around them. They grew along the mill race on his property.

LENT BY MRS. ANDREW WYETH

61 GERANIUMS

Dry brush
21 × 15 5/8 inches
Signed at lower right: Andrew Wyeth
Date: June 1960

The day was clear, summer blue. Although the house is weather-beaten, there is a joyous sparkle to the air brought out by the bright blooms on the geraniums.

The scene is the same as number 63, but with the focus on the window. The sun falls on the red geraniums against the far window. The distant blue sea is seen with the dark spruce branches outlined against it. Beyond the foreground window a white cloth covers the dishes. Christina Olson sits at the left between the table and the far window.

LENT BY MRS. ANDREW WYETH

62 VINAL'S POINT

A study of a long leg and a long-fingered hand, and a head and shoulders seen from the back.

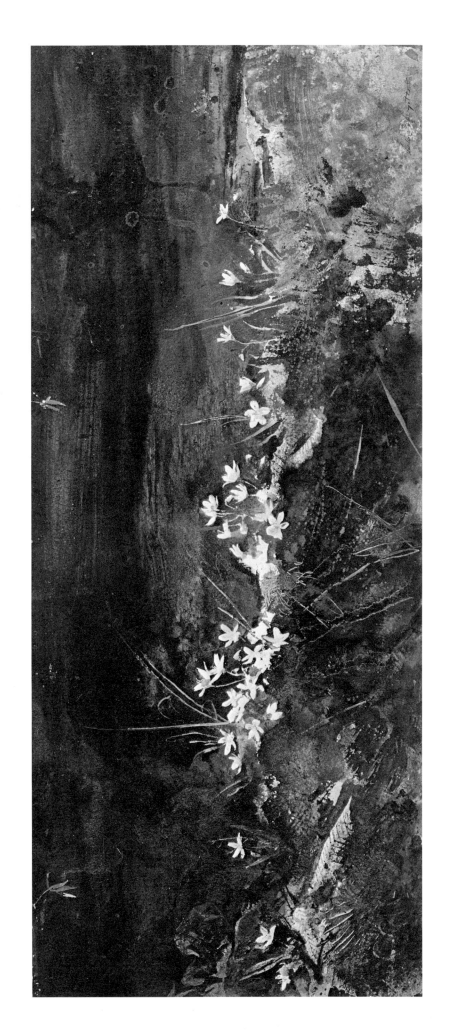

Ebony pencil
13¾ × 20½ inches (sight)
Date: July 1960

The drawing is a preparatory study for *Above the Narrows* in the Collection of Mr. Jack J. Dreyfus, Jr., New York City (reproduced in color: *Horizon*, vol. IV, no. 1, page 93; as *Nicky, 1960*). The model was the Wyeths' elder son, Nicholas. The tempera was completed by September 22, 1960, while its preparatory drawings were begun July 12, 1960.

63 NEW ENGLAND

At the left, above a single granite slab and two wooden steps, a door with a white doorknob opens into an empty hall. The storm door is open against the outer wall at the left. Through the single twelve-paned window in the weather-beaten wall a little right of center and beyond some bowls standing on a table and covered with a cloth, there is seen the back of the head and the shoulders of a woman wearing a blue and white striped blouse. She leans her head against her right hand and seems to be reading. She faces another window beyond which are the branches of an evergreen tree, dark against a pale sky. In the foreground, a wind from the right is blowing the tall, dry grass.

Dry brush
17¾ × 22½ inches
Signed at lower right: Andrew Wyeth
Date: September 1960

The figure is Christina Olson (number 3). This is the kitchen ell of her house, which you can see in numbers 4 and 61. Autumn has come bringing changeable weather and heavy sea fogs.

64 STUDY FOR "YOUNG BULL" ILLUSTRATED

Two quick sketches, one in pencil at left center, and one in wash above at right, of house and wall. To the left, two sketches of the young bull, standing with head turned sharp left.

Pencil and water color
14 × 16½ inches
Date: November 1960

A quick sketch of Karl Kuerner's house and wall, showing strong contrasts of light and shadow.

65 STUDY FOR "YOUNG BULL"

A pencil sketch which includes an indication of Karl Kuerner at the left with the young bull.

Pencil
11 × 16¼ inches (sight)
Date: November 1960

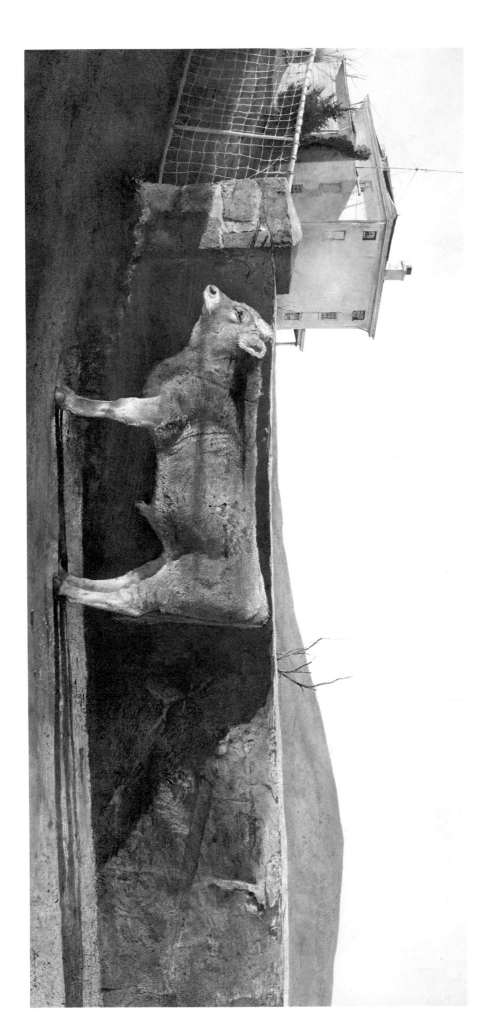

66 STUDY FOR "YOUNG BULL"

Watercolor
13 × 16¼ inches (sight)
Date: November 1960

It is not usual for Wyeth to make so many preparatory studies for a dry brush drawing as he has in the case of the Young Bull (see also numbers 64 and 65). Here the hill is olive-green, the wall gray. These colors faded as the winter came on, so that in the dry brush drawing (number 67) they are muted.

LENT BY MRS. ANDREW WYETH

67 YOUNG BULL ILLUSTRATED

The young bull stands facing the early morning light, silhouetted against a stone wall which is still in shadow where he stands. In the left background, above the square pillar of the stone wall which supports a primitive wire gate, is a large rectangular white house, its upper story catching the morning sun. Above the wall, just behind the young bull, the bare branches of a low tree or shrub are silhouetted against the sky and the gentle rise of a barren hill.

Dry brush in gray, yellow, white, brown, and green
19⅞ × 41⅜ inches
Signed in ink at the lower right: Andrew Wyeth
Date: Worked on through November until December 20, 1960

The house is Karl Kuerner's (see number 37) and the hill is the same shown in number 2. While Wyeth was working on the dry brush, the bull suddenly kicked the artist's palette.

Color went flying! A splash of it can be seen on the bull's hind quarters. It resulted in one of those "happy accidents" that the artist decided to leave.

LENT BY MRS. ANDREW WYETH

68 HANGING DEER ILLUSTRATED

The dead deer, a rope around his neck, hangs from a bare branch of a willow tree. The shadow of the tree falls at an angle across the snowy foreground.

Dry brush in brown, gray, and white, with a touch of strawberry red
21¹³⁄₁₆ × 13⅞ inches
Date: January 1961

This drawing is a preliminary study for the tempera painting *Tenant Farmer* in the Collection of Mr. and Mrs. W. E. Phelps, Montchanin, Delaware (reproduced in color: *Horizon*, vol. IV, no. 1, pp. 90–91). Wyeth, in the *Horizon* article, tells how he happened to see the deer hanging from the tree in the snow and how the subject haunted him until it became a symbol to him. "Finally," he says, "I had to do the painting just to get it out of my mind." The bare branches of the willow tree evoked in the artist the memory of early tombstones. He remembers, too, that its branches crackled in the wind as he made the drawing, adding to the eeriness of the occasion. The tempera was completed by April 1, 1961.

LENT BY MRS. ANDREW WYETH

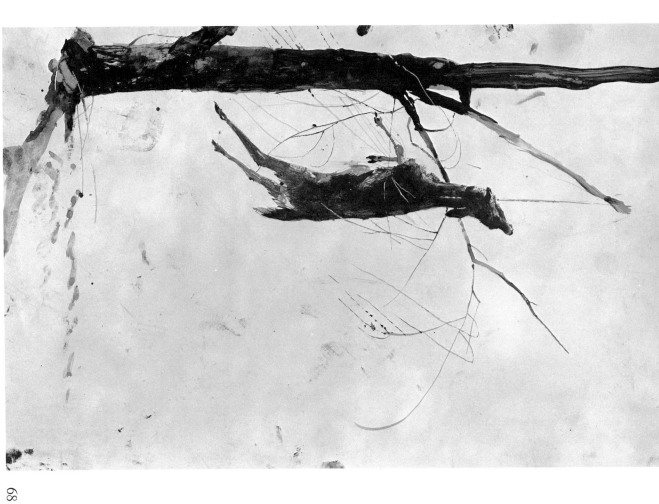

69 BRICK HOUSE

At the left is a bare willow tree (see number 68). The brick house has a big chimney above its pitched roof. Snow is blowing off the eaves and there is an effect of deep snow around the house. An icicle hangs from the little porch at the left. The shed behind the house is indicated at the right.

Dry brush in red, brown, and gray
13½ × 21 inches (sight)
Date: January 1961

LENT BY MRS. ANDREW WYETH

The brick house is one of the early ones in the Chadds Ford region and is said to date back to William Penn's time. The drawing is a preparatory study for the tempera painting *Tenant Farmer* (see also number 68).

70 JOHN

The sitter is seen, head and shoulders, in profile toward the left. He has olive skin and almost crow-black hair, graying a little at the edges. He wears a tan jacket over an olive-green sweater. The background is warm gray.

Dry brush
11¼ × 15¼ inches
Date: Late April 1961

The drawing represents John McCoy, the brother-in-law of the artist.

LENT BY MR. AND MRS. GEORGE WEYMOUTH

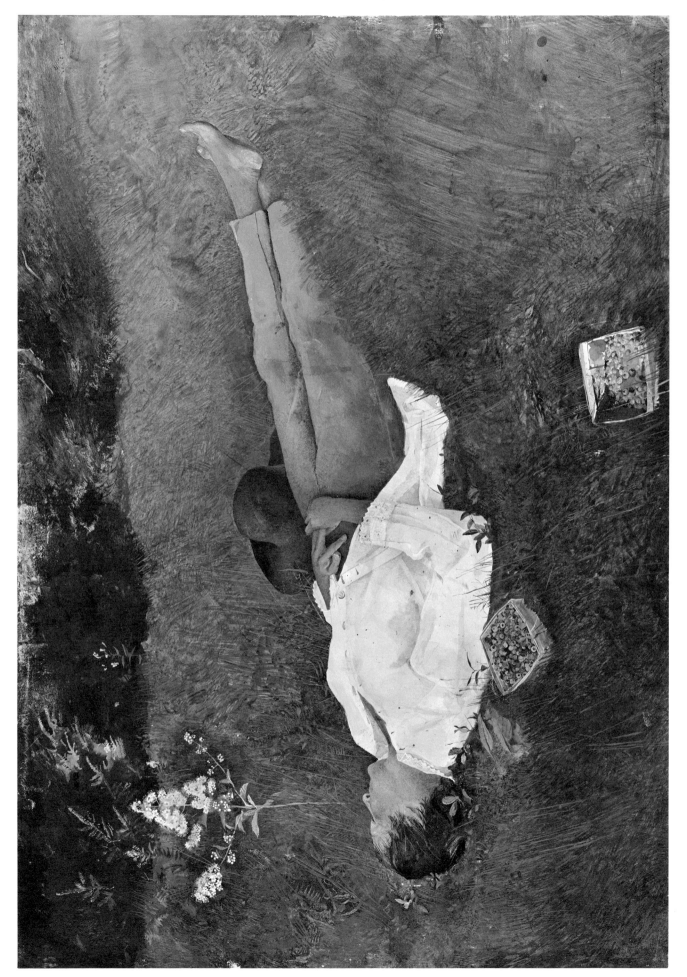

71 SLEEP

Wearing a white shirt with embroidery edged collar and cuffs and long gray trousers, the figure is on her back at a gentle diagonal from near the lower left to near the upper right. Her right hand holds three small fingers of her left hand, her eyes are closed, her head turned slightly inward. Two berry boxes, partially filled, lie in the grass in the foreground. A large chocolate-brown felt hat lies at her side. A single flowering stalk of meadowsweet blows above her face; the upper grass is deep in shadow across the top in a line parallel with the figure.

Dry brush in many colors
20¾ × 28¾ inches
Date: July 1961
Reproduced: Art in America, vol. L, no. 2, Summer 1962, in color, p. 40

The drawing, which shows Mrs. Wyeth asleep, is a preparatory study for the tempera painting *Distant Thunder*, Collection of Mrs. Norman Woolworth, Winthrop, Maine. Rattler, the Wyeths' dog, appears in the painting. While Mrs. Wyeth slept, he lifted his head and put up his ears, listening to the distant thunder. The drawings were begun July 1, 1961 and the tempera completed October 1, 1961.

LENT BY MRS. ANDREW WYETH

72 GARRET ROOM

A thin, aged Negro lies resting in a garret room on a silk patchwork quilt, his pillow an old sugar bag. Behind him the wall is blue. A white cloth hangs above his head. An apple basket is on the chair, which holds a shirt.

Dry brush in many colors
17½ × 22½ inches (sight)
Date: December 1961–January 1962

The sleeping man is Tom Clark (see numbers 49 and 55) who has posed many times for Wyeth. The silk patchwork was made by Tom Clark's grandmother.

LENT BY MRS. ANDREW WYETH

73 THE GRANARY

Two simple stone buildings, gray-brown in tone, the larger one at the left, dominate the middle distance. A third one is visible at the extreme right. The far bank of the mill race is visible at the extreme left with woods beyond. Snow covers the roofs and the wood pile at the right and snow flurries fill the air. There are three pigeons on the chimney of the mill building and three more on the cover of the hoist.

Dry brush on heavy white paper
13⅞ × 21⅞ inches
Date: February 1962
Reproduced: Art in America, vol. L, no. 2, Summer 1962, in color, p. 48 (as *Brinton's Mill*)

The building in the foreground is where the Wyeths live. The mill to the left dates back to the early 1700's. Out of view is the mill house (see numbers 56 and 57).

LENT BY MRS. ANDREW WYETH

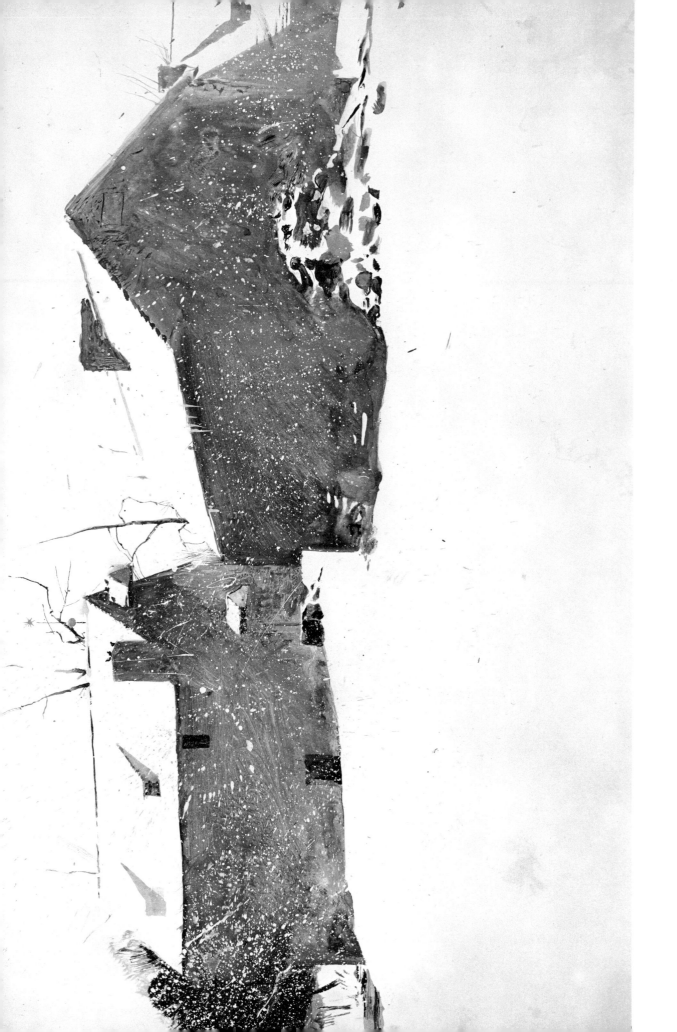

PRODUCED BY

THE MERIDEN GRAVURE COMPANY

AND THE STINEHOUR PRESS